John James
Audubon
American Birds

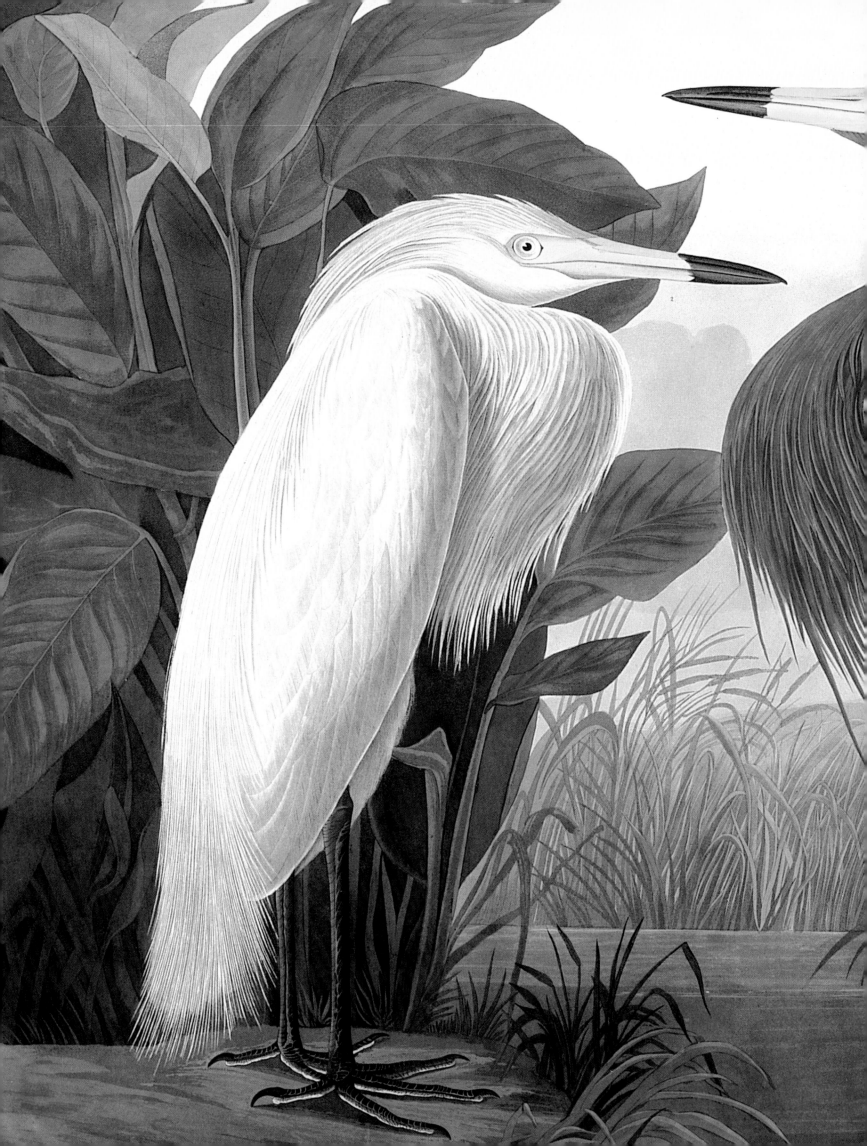

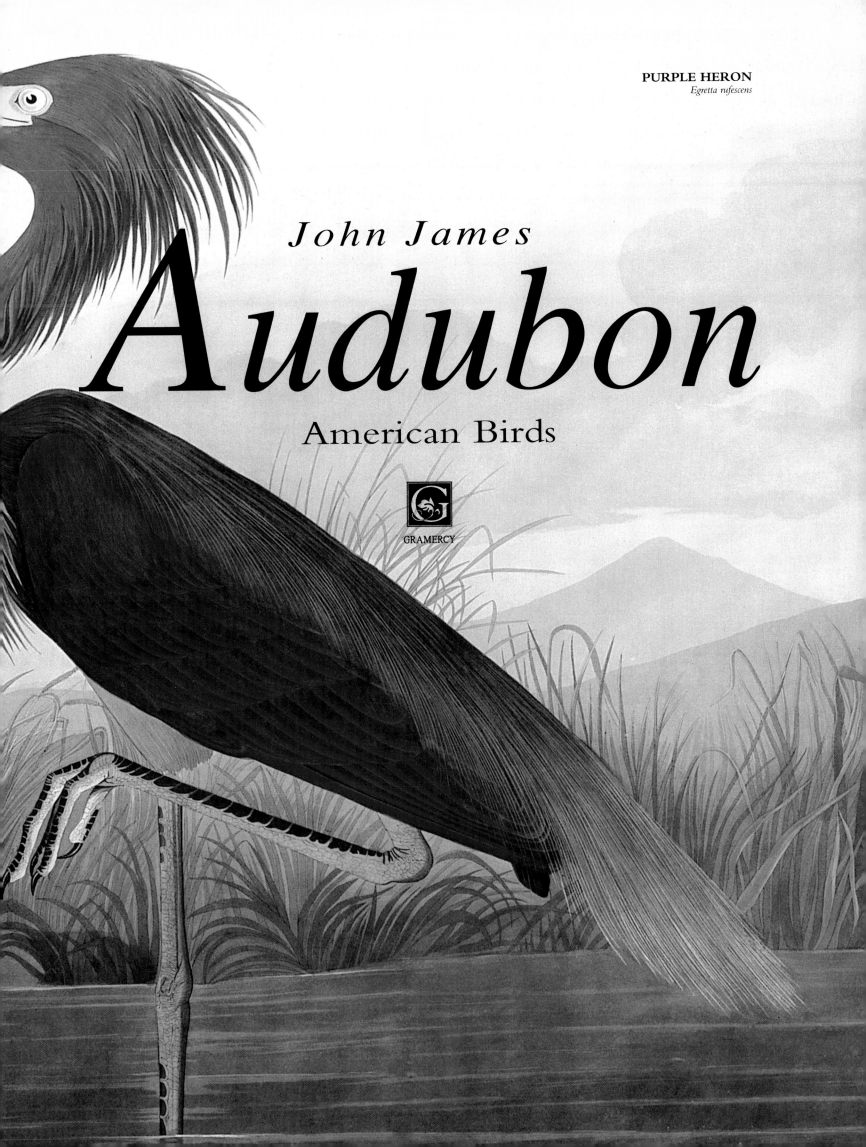

PURPLE HERON
Egretta rufescens

John James
Audubon

American Birds

GRAMERCY

COLUMBIA JAY
Calocitta coliei

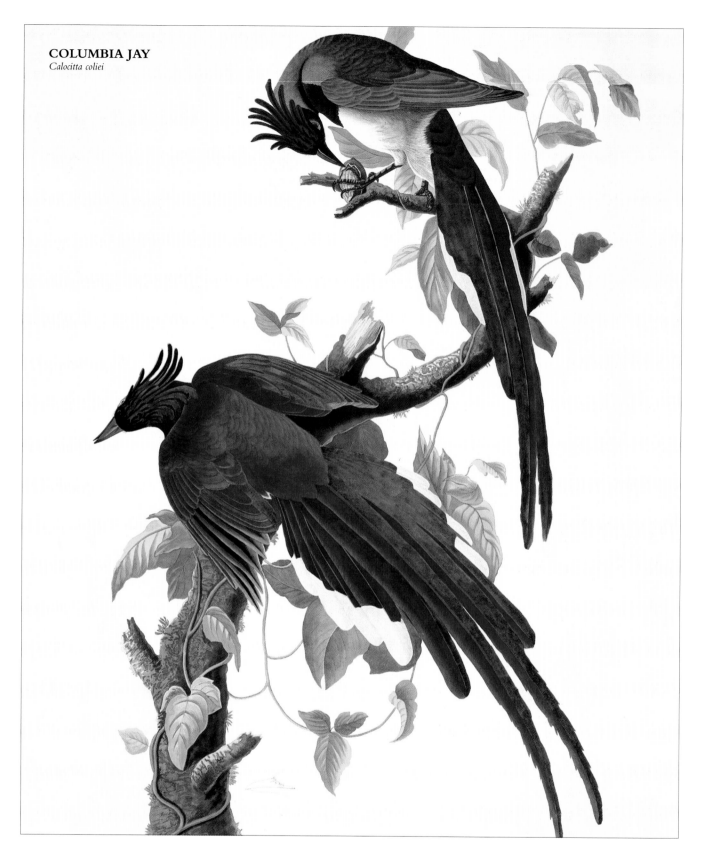

This 1999 edition is published by Gramercy Books™, an imprint of Random House Value Publishing, Inc., 201 East 50th Street, New York, NY 10022

Gramercy Books ™ and design are trademarks of Random House Value Publishing, Inc.

Random House New York • Toronto • London • Sydney • Auckland
http://www.randomhouse.com/

Printed in Singapore

ISBN 0-517-16117-6

10 987654321

List of Plates

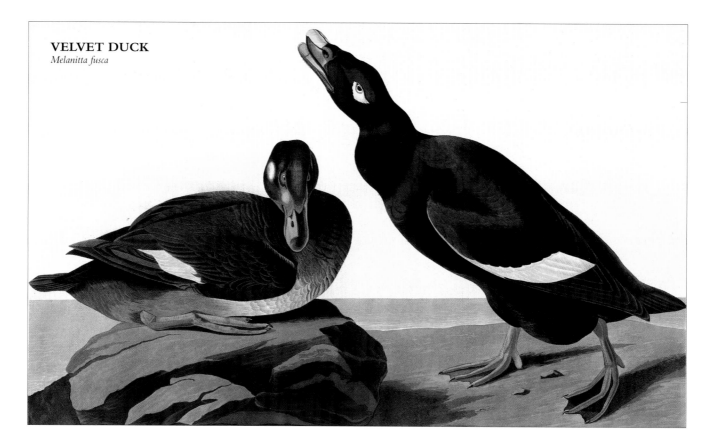

VELVET DUCK
Melanitta fusca

The results of a period of world exploration were consolidated in the late 17th and early 18th centuries when descriptions of newly discovered animals and plants were published in a series of great works. The brightness and variety of colours and patterns made birds a particularly favoured subject for illustrated books. Large multi-volume works were often sold to which purchasers were asked to subscribe, receiving many small parts, usually a section of pages or some illustrated plates, which might be printed over several years. The purchaser would then have them bound to form a book. Subscriptions were needed to ensure that the parts continued to appear, and authors were simultaneously hunting subscribers, even while they were collecting information and writing or illustrating their books.

It was against this background, having failed to get the support that he needed in his own country, that in 1826 John James LaForest Audubon appeared in Liverpool, England, dressed for effect as an American backwoodsman and with an impressive portfolio of his paintings to exhibit. He travelled to Edinburgh where exhibitions of his work attracted favourable public interest. He was aware that Alexander Wilson's mainly textual work on American birds would already be known and needed to outshine it. Audubon's vivid bird portraits, full of movement and vitality, caught the imagination, and he daringly proposed to

illustrate the American birds on the largest available paper size, double elephant folio, which would allow most species to be shown life-size. It was a huge proposition.

This was Audubon's first great venture into the field of bird portraiture. He had had a varied past, having been born nearly 40 years before, in 1785, at Les Cayes, Saint-Dominique, on what is now the island of Haiti. His father was a sea-captain, Jean Audubon, and his mother Jeanne Rabine died shortly after the birth. He spent his childhood and schooldays in France, though he appears to have had a rather scanty formal education. However, he became interested in wildlife through hunting and drawing what he saw. In 1803, when he was in his late teens, his father persuaded him to return to manage his farm: John James took charge of the farm at Mill Grove near to what is now the town of Audubon, near Norristown, Pennsylvania and effectively began his life as an American.

He continued to study the wildlife around him, particularly the birds. He also began his technique of supporting dead birds on wires so that he could paint them in various postures. He married a neighbour's daughter, Lucy Bakewell, and had two sons and later a daughter. Although he does not seem to have had a good head for business, he nevertheless saw himself as a great entrepreneur and merchant and embarked on a series of unsuccessful ventures.

The inspiration for a work on birds may have been

triggered by a chance meeting with Alexander Wilson. Wilson was a Scotsman who had travelled to America in 1794 at the age of 28. At that time he had only 19 years further to live before he was to die of tuberculosis; but during the time he became a serious ornithologist and produced a nine-volume work on American birds, describing many for the first time. He travelled in search of birds and subscriptions, visiting Louisville in 1809. Audubon, who was at that time managing a store, met him in March 1810 and saw some of his work. They do not appear to have responded well to one another, and although nothing came of the meeting it may have given Audubon the idea that he could do better.

Only about nine years later does Audubon appear to have envisaged and embarked upon his great work. For the next five years he travelled in search of birds, neglecting family and business to spend time on bird observation and drawings for his portfolio. It was during this period of backwoods wandering that he acquired his reputation as 'the American Woodsman', emulating the tradition of Crockett and Boone, both of whom he admired enormously.

Financial necessity brought an end to his wanderings, and the early 1820s found him painting portraits and teaching art at the school in Louisiana that his wife Lucy had founded. He endeavoured to get to know scientists and academics, but was regarded as an eccentric and not always taken seriously. His ambition, and the artistic work he was accumulating, however, failed to inspire support in America, and in 1826 he turned to Britain.

In Edinburgh he was fortunate in meeting a well-known engraver, William Home Lizars, who produced the first parts of the book, ten large aquatint engravings in fine and careful colour. He also taught Audubon some of the background of printing and selling. With something to show as an example, Audubon travelled south to London, seeking subscriptions at towns visited on the way. His reputation had preceded him and in London he found a new engraver, Robert Havell, who had the knowledge and ability to turn Audubon's dream into a reality. Audubon was involved in work and travel for the book for about ten years, visiting

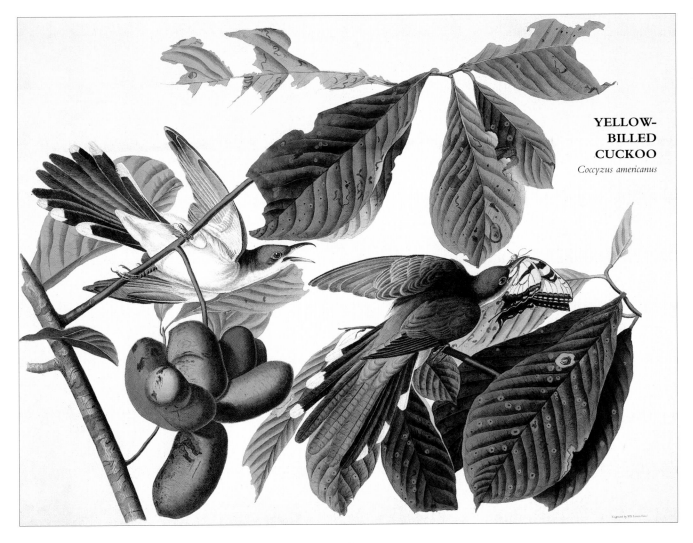

YELLOW-BILLED CUCKOO

Coccyzus americanus

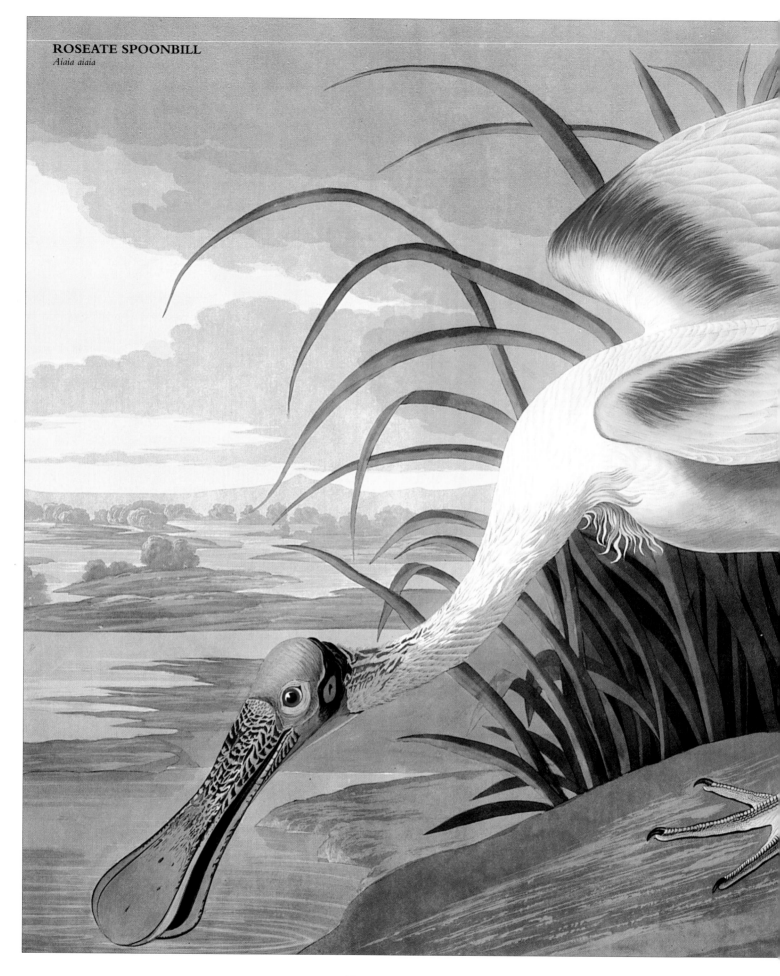

ROSEATE SPOONBILL
Aiaia aiaia

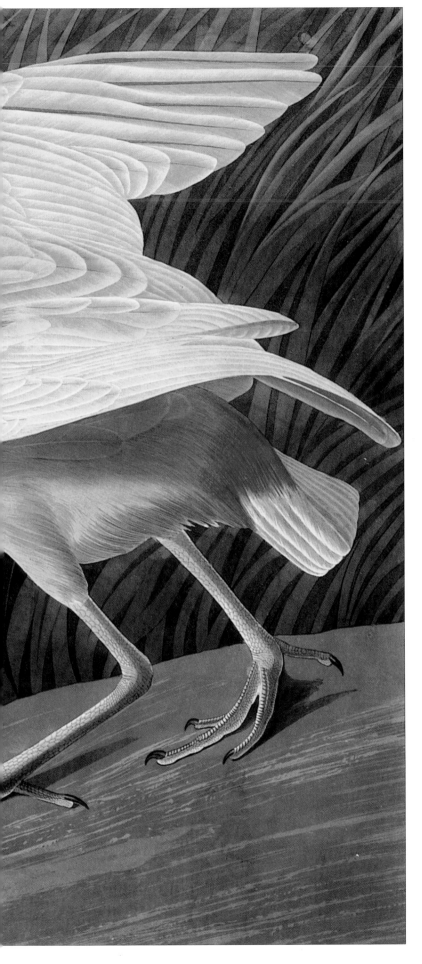

France to obtain the help of eminent individuals, and travelling more than once to America. He journeyed from the Atlantic coasts to Florida and Texas, and had access to newly collected specimens from the American West, enabling him to produce more new pictures.

His work appeared as 87 parts of five plates each, 435 in all, with about 1063 mostly life-sized figures. It was planned as four volumes, *The Birds of America*, and published over 11 years, 1827–38. Throughout the work, Audubon had striven to show his birds in vigorous activity of some kind, as though caught in motion, and within their natural environment. Bird artists have always had the problem of recording fleeting postures and feather movements together with the finer details of feather and pattern. Audubon tried to solve this by using recently-dead birds suspended by wires to give them a semblance of being still alive. Unfortunately, the postures were at times over-exaggerated, and one contemporay ornithologist criticized his 'addiction to birds in violent action and in postures that outrage nature'.

In spite of this, his work was an important contribution to the knowledge and appreciation of birds, and made him the figurehead of American ornithology. We do not know how many complete sets of his pictures were made into books, but around 200 has been suggested. His work brought him widespread fame and recognition but it did not produce the wealth for which he had hoped. He returned to America and planned a smaller, folio-sized, edition of his bird book. He had also produced an *Ornithological Biography* and now began a new venture to produce a folio-sized version of *The Viviparous Quadrupeds of North America*. However, his work began to be affected by deteriorating eyesight and he increasingly came to rely on the help of his son John, both in collecting specimens and in painting them. He died in 1851, frustrated by his increasing disabilities.

Wilson had identified and described American birds, Audubon had made them visible. Audubon's achievement was to make the world of American birds a vivid reality for those fortunate enough to have access to his work. The lively portraits and additional views of native plants and scenes managed to provide even Europeans with a sharp insight into the natural world of the American continent. His work still inspires – even though present bird artists have given us more detailed and less idiosyncratic visions. As an attempt to depict wild birds, and when one considers the division between artistic and scientific illustration, the following examples stand predominantly as works of art that will continue to endure and delight.

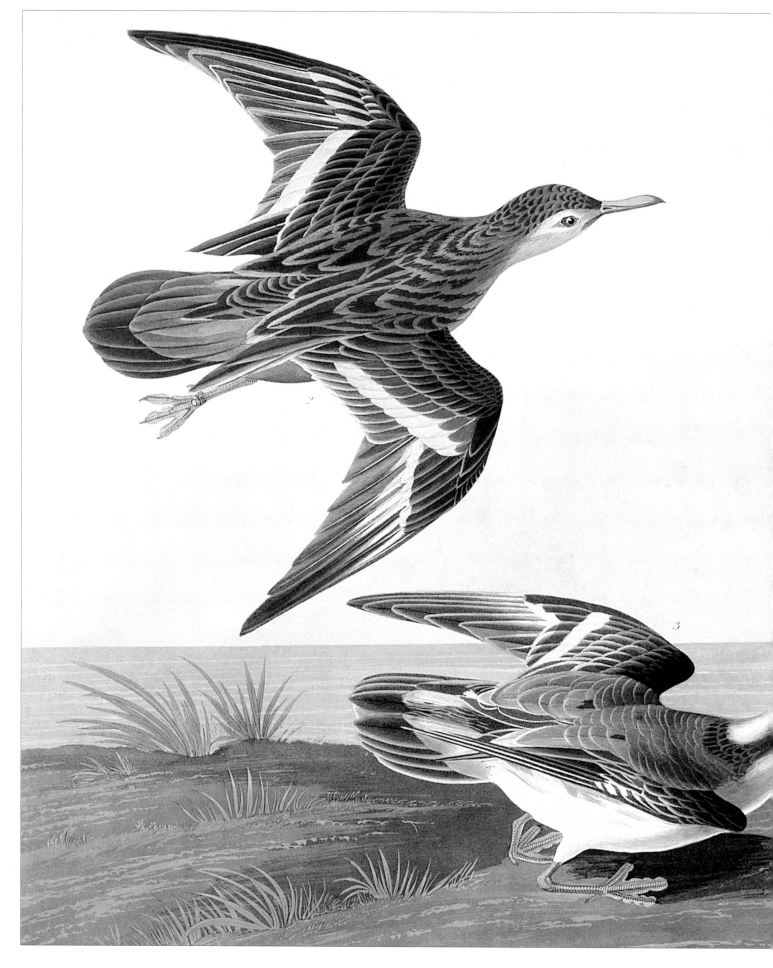

RED PHALAROPE
Phalaropus fulicaria

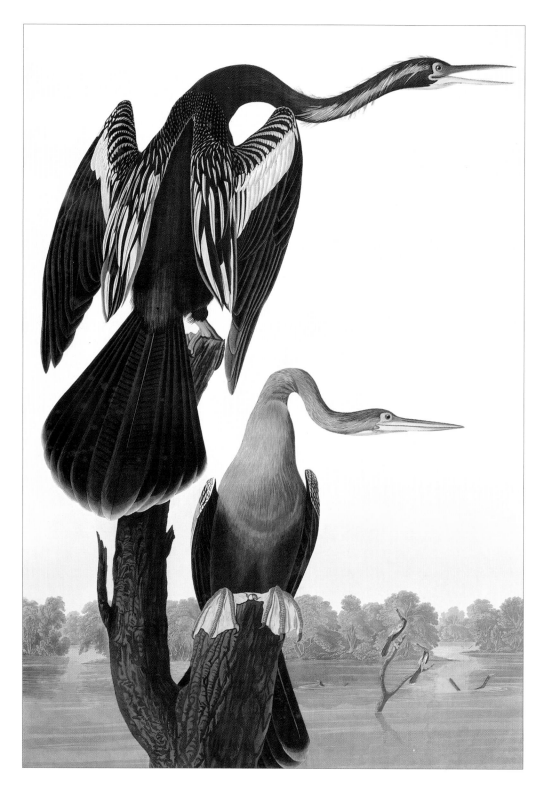

PLATE 1 above
BLACK-BELLIED DARTER (ANHINGA)

Anhinga anhinga. 35 inches (89cm). To be found on waters of all kinds, preferably freshwaters, sometimes brackish or salt. **Distribution:** Resident in Florida and on the Gulf coast. Breeds in the Gulf states and east to the Carolinas. **Food:** The bird dives for fish, spearing them with its bill. **Nesting:** Often in colonies in small shallow twig nests in trees and shrubs. 3–5 bluish-white eggs.

PLATE 2 opposite
BROWN PELICAN

Pelicanus occidentalis. 48 inches (122cm). A pelican of coastal saltwaters. **Distribution:** Breeds on coasts of the United States and is resident from the Carolinas to California. **Food:** Plunge-dives for fish. **Nesting:** In colonies on small coastal islands. Uses various accumulations of materials on ground, in bushes or trees. 2–3 dull white eggs.

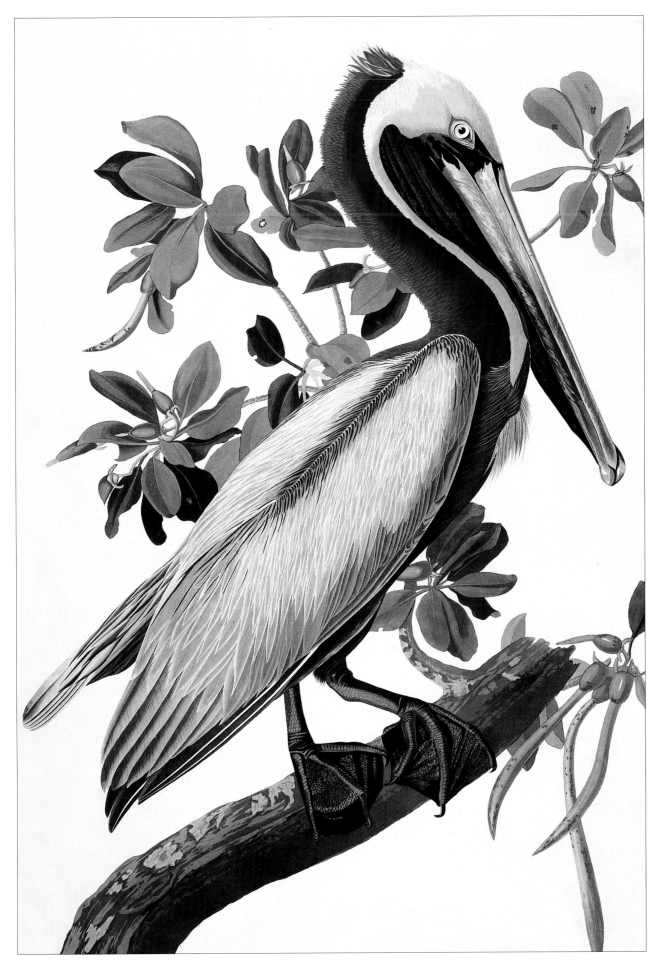

PLATE 3 right
DOUBLE-CRESTED CORMORANT (FLORIDA CORMORANT)

Phalacrocorax auritis. 52 inches (132cm). Widespread on inland lakes and rivers, and on rocky coasts and beaches. **Distribution:** In summer, often resident around coasts and in suitable areas of southern Canada and the United States, overwintering coastally, southwards towards the Gulf of Mexico. **Food:** Dives for fish. **Nesting:** On a large mass of twigs and debris with a finer lined cup, on rocks or in trees, on islands, cliff ledges near lakes and swamps. 2–7 pale-blue eggs.

PLATE 4 below
AMERICAN WHITE PELICAN

Pelecanus erythrorhyncos. 62 inches (158cm). Surface-feeding bird of larger lakes and marshes. **Distribution:** Breeds on islands in lakes in the central to western areas of North America, wintering from the southern United States to Central America. Breeds in colonies on low, often bare islands in fresh or salt water. **Food:** The birds fish in groups, dipping down through the surface of the water. **Nesting:** On large mounds of hollowed-out debris. 1–2 white eggs.

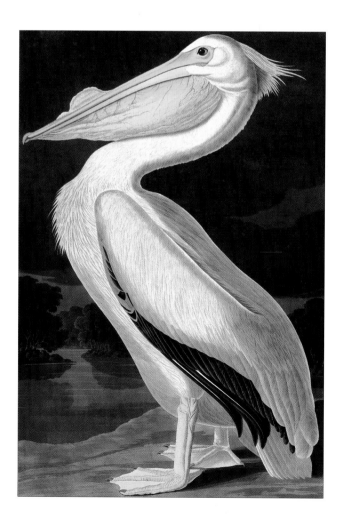

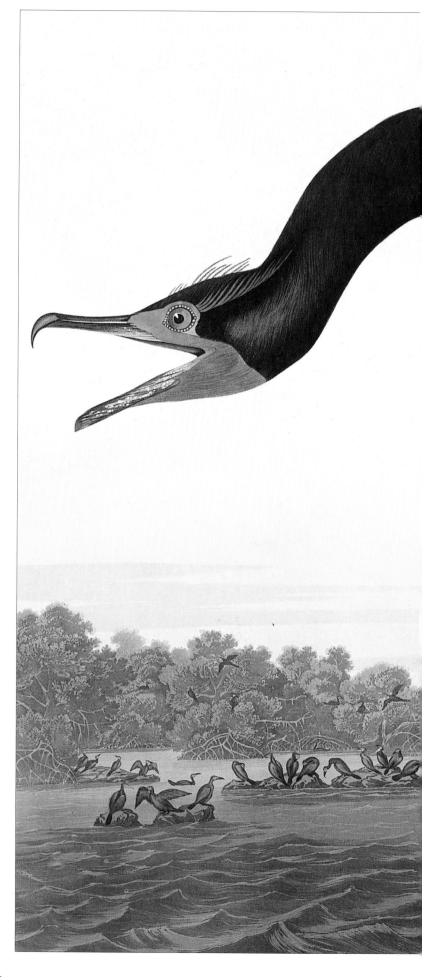

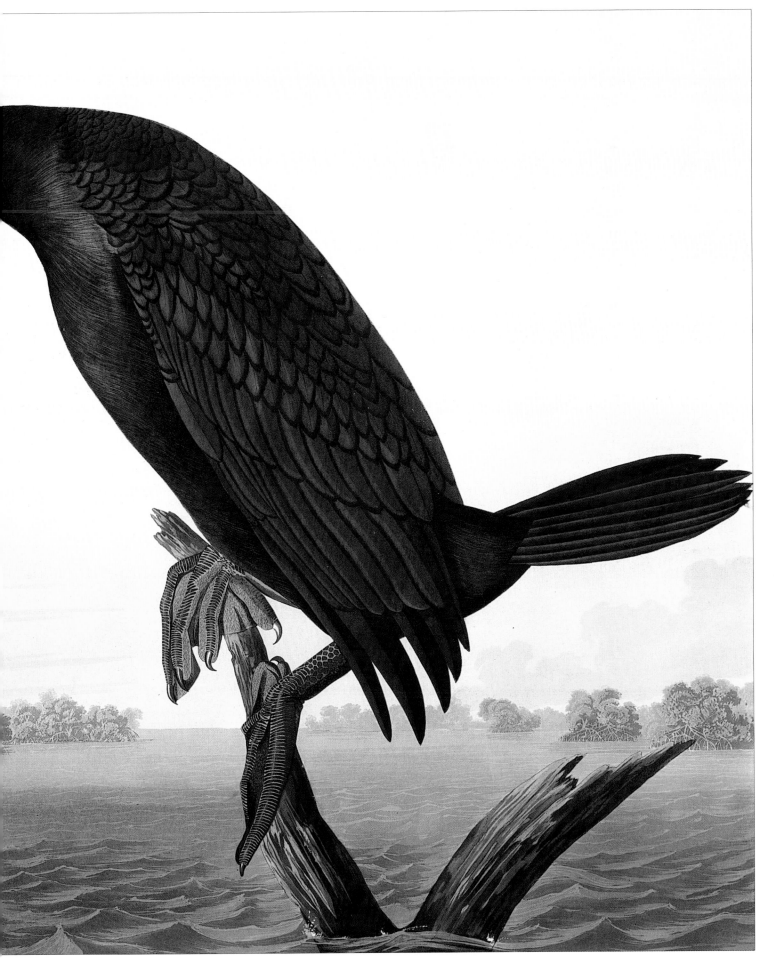

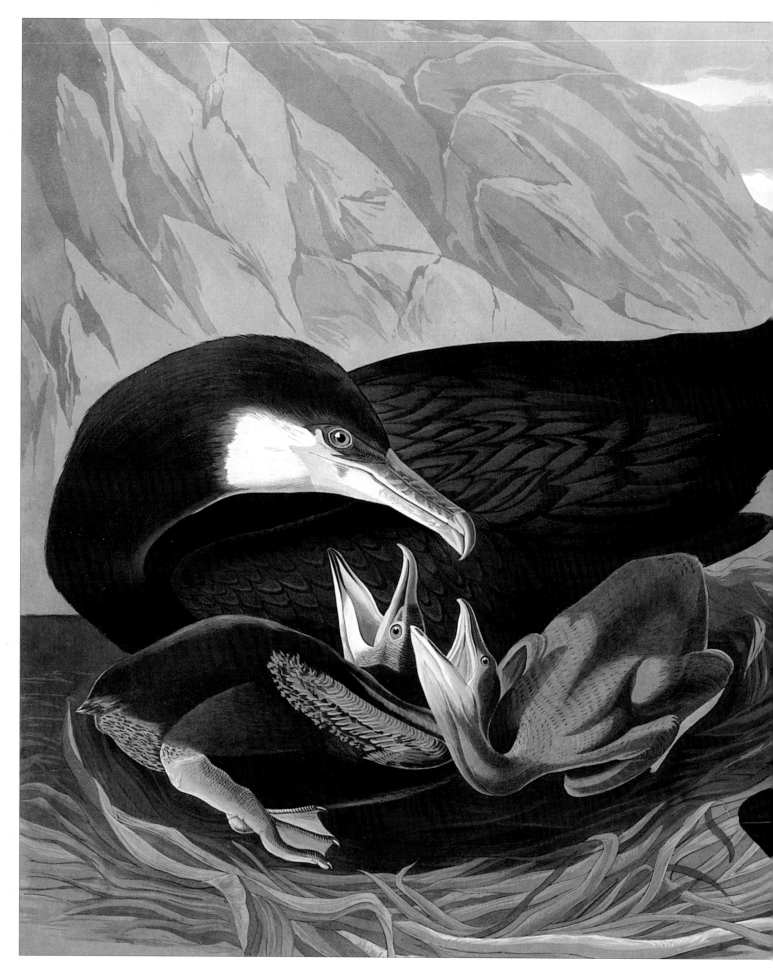

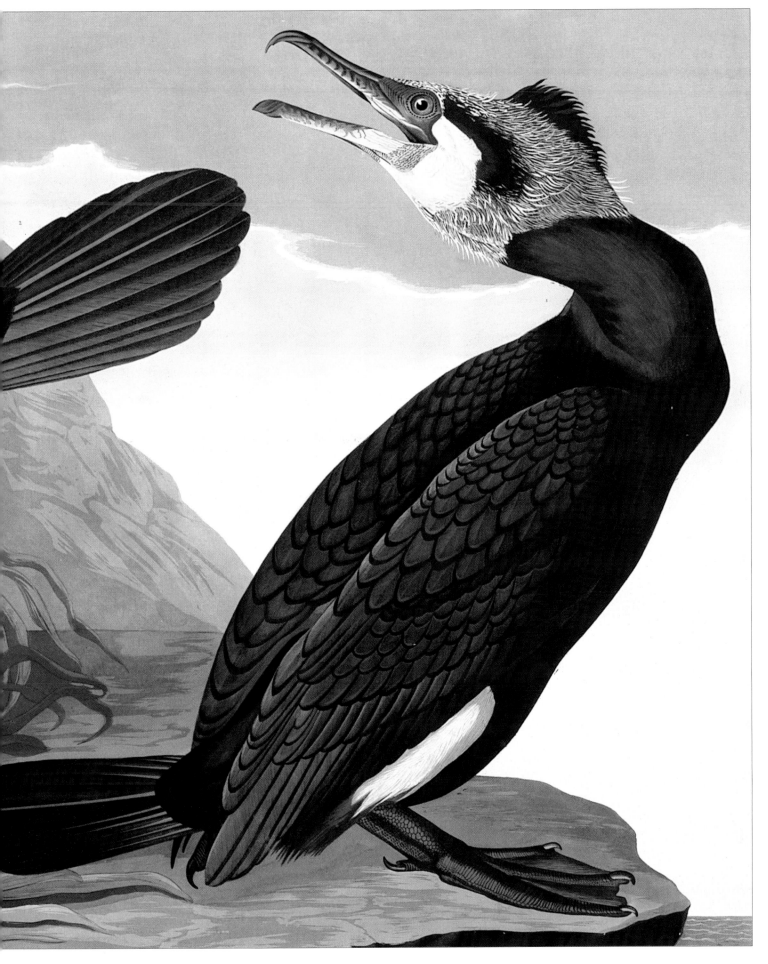

Pages 20-21

PLATE 5

COMMON CORMORANT (GREAT CORMORANT)

Phalocrocorax carbo. 36 inches (91cm). Can be found on rocky coasts and estuaries. **Distribution:** Lives and breeds from Labrador to Nova Scotia and Newfoundland, wintering down the east coast of the United States. **Food:** Mainly fish with other marine creatures. **Nesting:** On a heap of weed and sticks within a slight depression, on ledges, rock surfaces or in trees. 3–4 pale-blue eggs.

PLATE 6 right

GOOSANDER (COMMON MERGANSER)

Mergus merganser. 25 inches (64cm). A large saw-bill diving duck of freshwater rivers, lakes and large ponds.
Distribution: Breeding in Canada, Alaska and the northern United States, it overwinters mainly in the United States.
Food: Dives to capture fish. **Nesting:** In a hollow nest lined with down, in a cavity in a tree or rock, or in a hole in a bank. 7–14 creamy-white eggs.

Page 24

PLATE 7

HUTCHINS'S BARNACLE GOOSE

Branta canadensis. Hutchins's Barnacle Goose is one of the small subspecies of Canada Goose from central and western Canada. (See note to plate 8).

Page 25

PLATE 8

CANADA GOOSE

Branta canadensis. 25–45 inches (64–114cm). Widespread, there are local subspecies which vary in size. They are inhabitants of tundra, muskeg, marshes, grassland and forest pools. **Distribution:** Breeds throughout North America, apart from the southern states, wintering in the southern two-thirds of the United States. **Food:** Grass, grain, seeds and roots. **Nesting:** In hollows lined with twigs and plants together with a layer of down, on ground near water or on a ledge, stump or old raptor nest. 5–6 white or cream eggs.

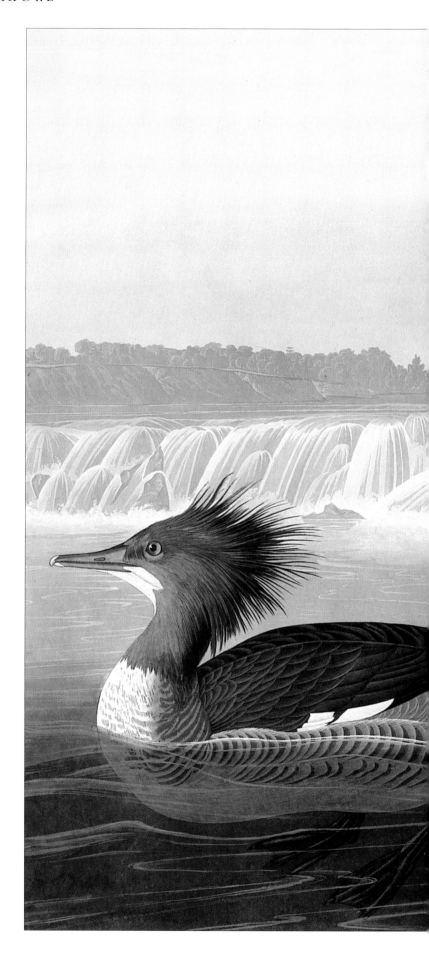

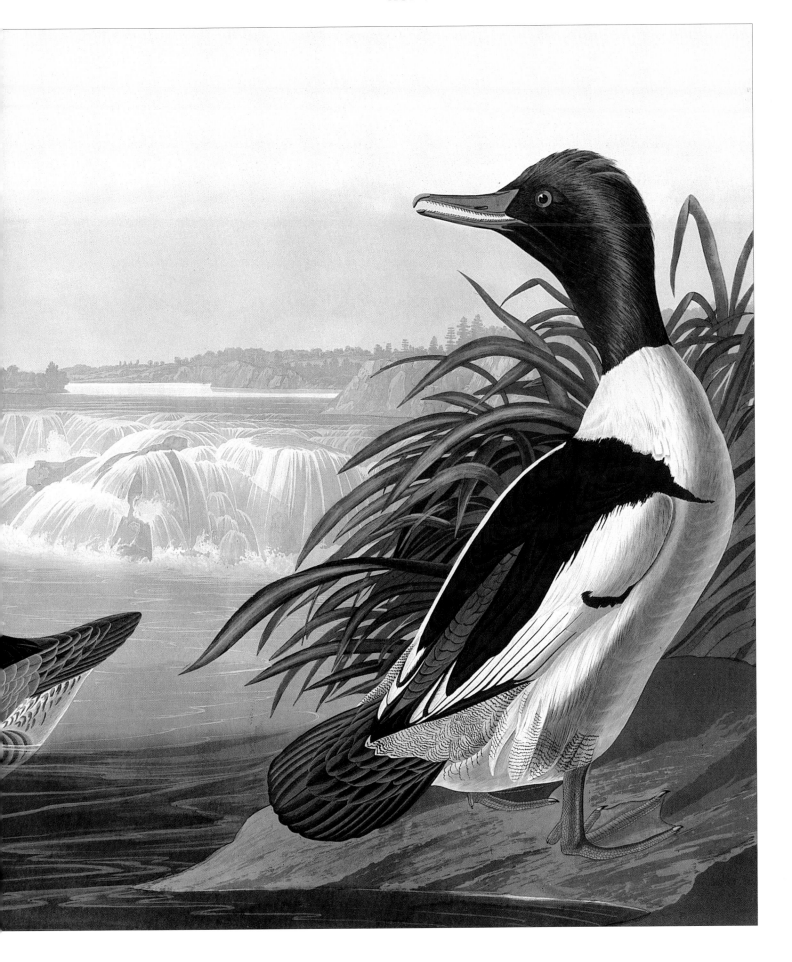

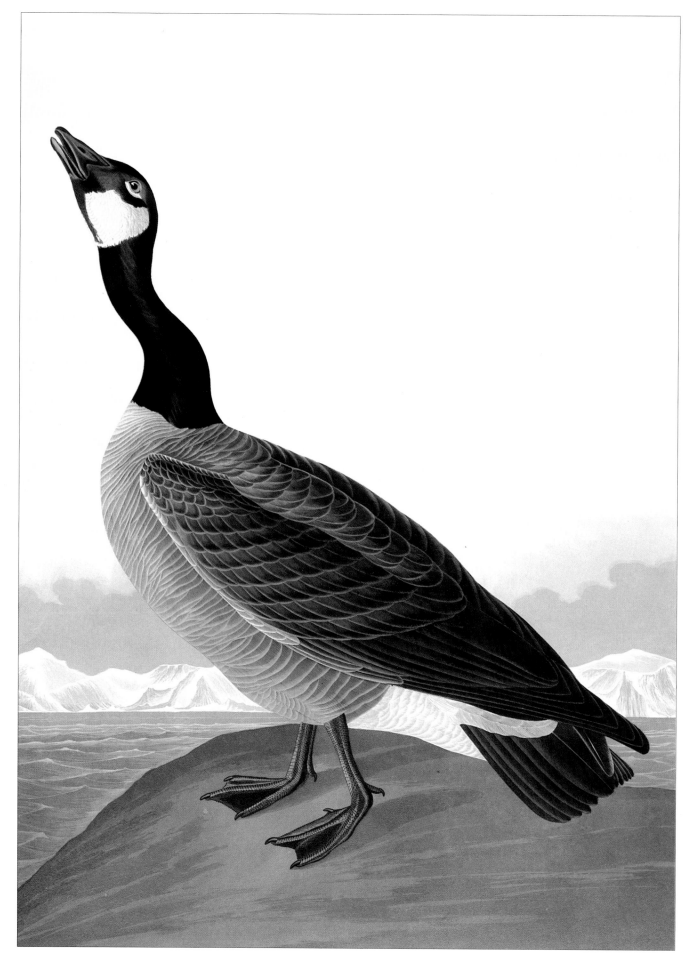

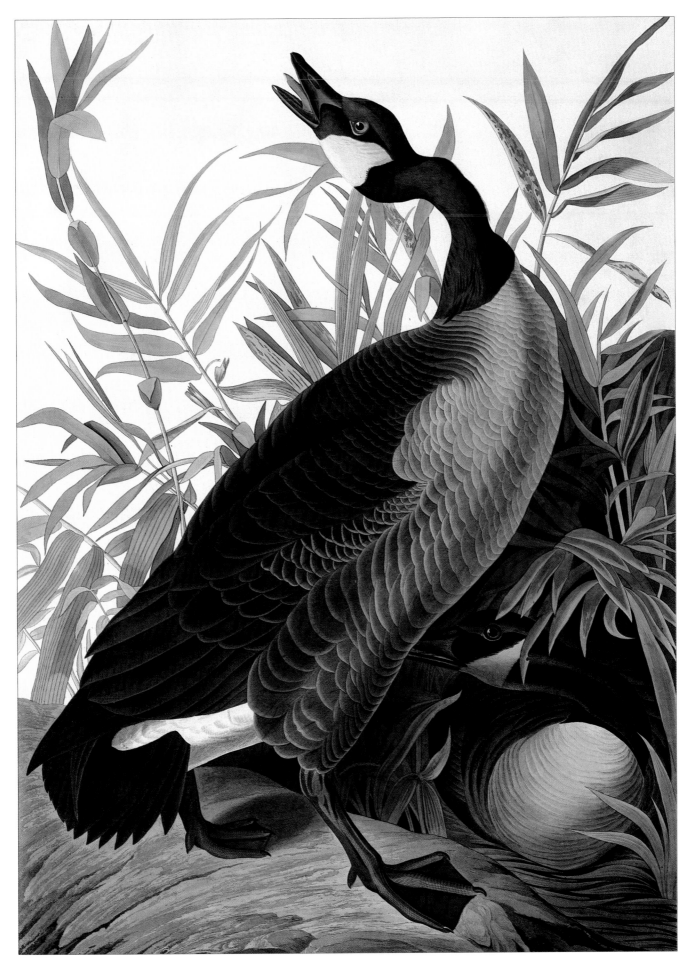

PLATE 9 right

AMERICAN WATER OUZEL
(NORTH AMERICAN DIPPER)

Cinclus mexicanus. 7 inches (19cm). Occurs by fast-running streams and rivers, feeding in and beneath the water. **Distribution:** Resident in western North America. **Food:** Invertebrates, tiny fish and eggs. **Nesting:** In a bulky domed moss ball with inner cup, in a crevice or on a ledge overlooking water. 4–5 white eggs. *Figs. 1 Male, 2 Female.*

Page 28

PLATE 10

SMEW or WHITE NUN

Mergellus albellus. 16 inches (41cm). This species breeds in Eurasia and is a rare visitor to the eastern and Aleutian regions of North America.

Page 29

PLATE 11

SUMMER or WOOD DUCK

Aix sponsa. 19 inches (47cm). An inhabitant of small waters, pools and open woodland lakes, and other wooded areas. **Distribution:** Breeds throughout America and into southern Canada, wintering in the southern United States but absent from most central plains and mountains. **Food:** Seeds, nuts, green plants and small creatures. **Nesting:** In cavities in trees, sometimes in old woodpecker holes, down-lined, or in nest-boxes. 8–10 white eggs.

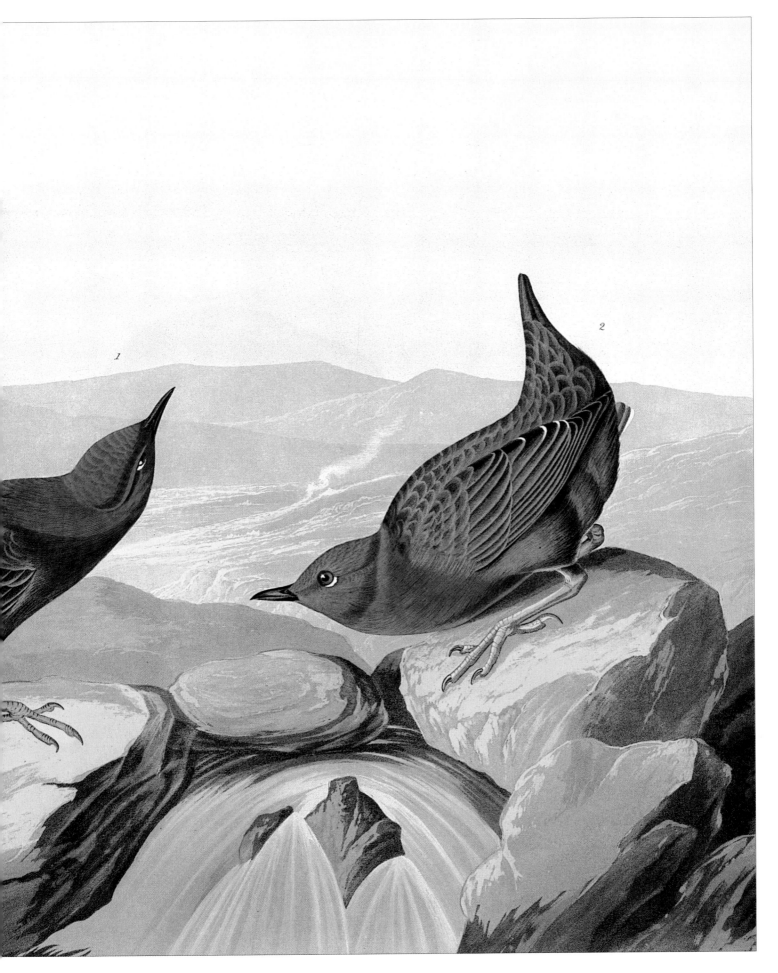

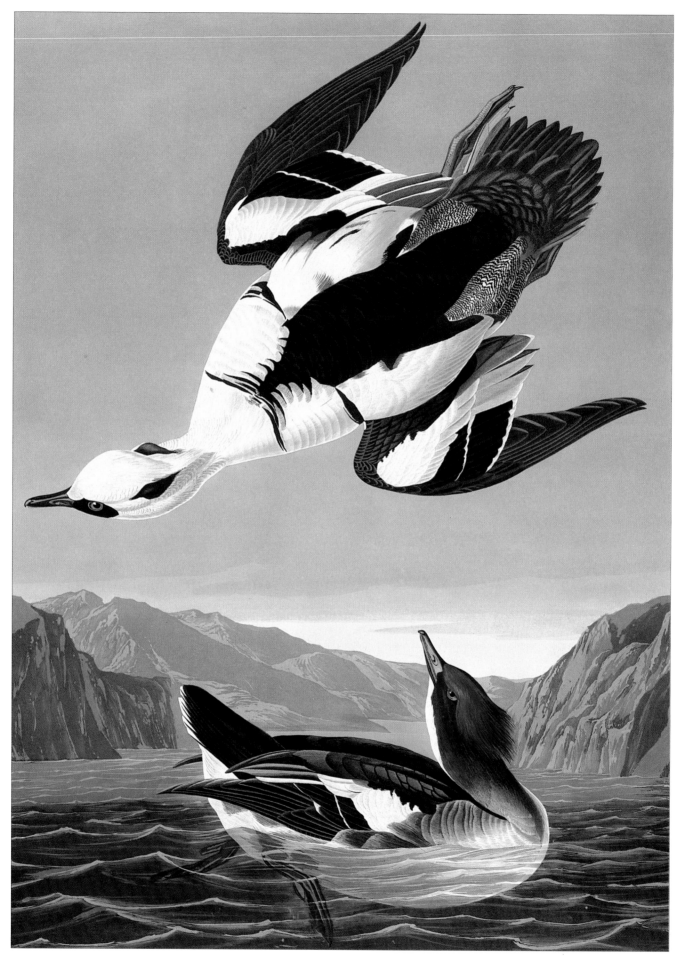

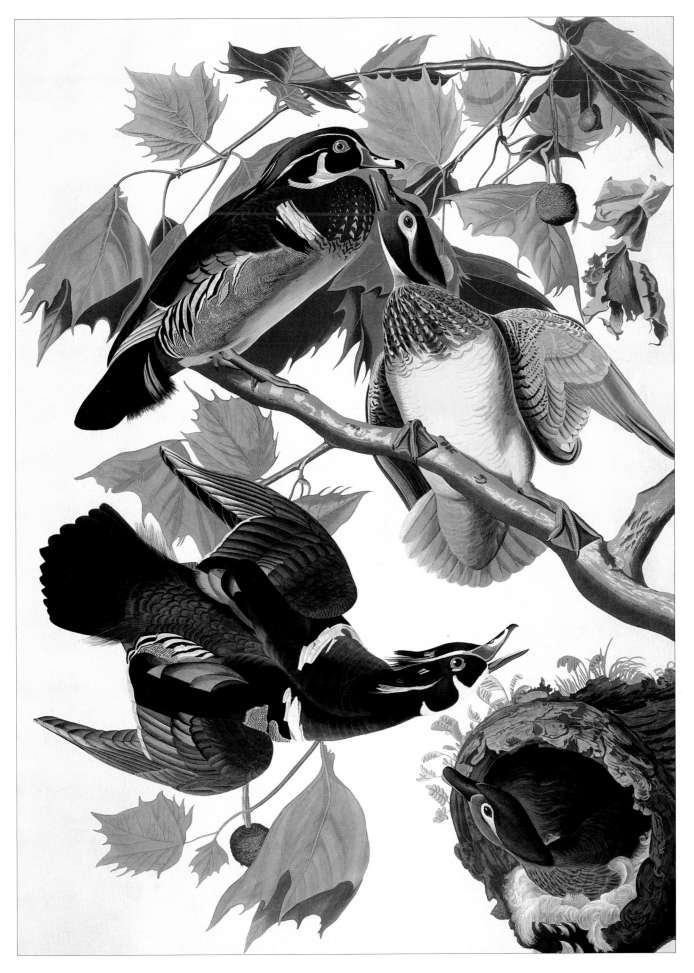

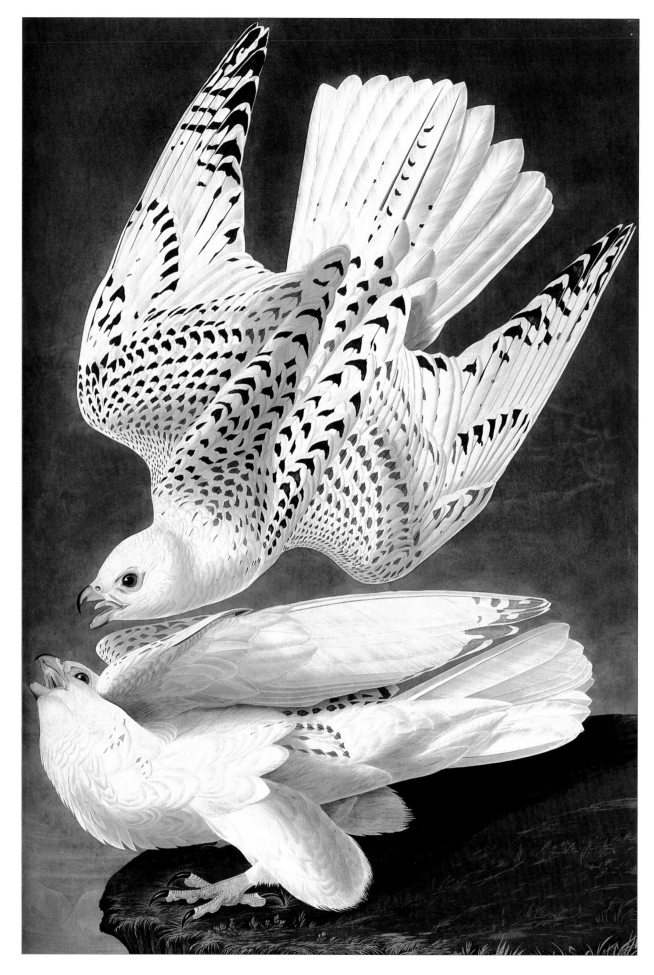

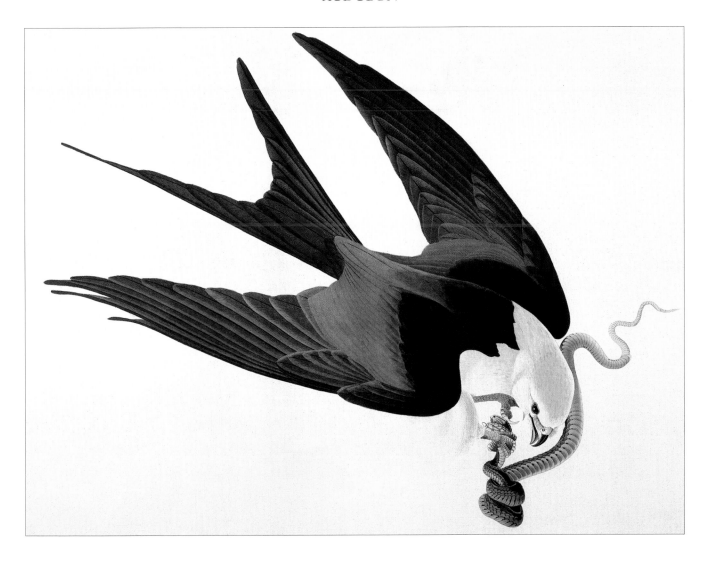

PLATE 12 opposite
GYRFALCON (LABRADOR or ICELAND JER FALCON)

Falco rusticolus. 20–25 inches (51–64cm). A large falcon inhabiting tundra where there are rocky outcrops, cliffs or gullies. **Distribution:** Resident throughout the tundra regions of Canada and Alaska, wandering to the Canadian borders in winter. **Food:** Hunts vertebrates, mainly birds and especially ptarmigan. **Nesting:** In an unlined scrape on a ledge or eminence. A batch of 3–4, sometimes 2–8 buffish eggs with reddish spotting.

PLATE 13 above
SWALLOW-TAILED HAWK (AMERICAN SWALLOW-TAILED KITE)

Elanoides forficatus. 23 inches (58cm). A sociable and agile bird of prey, an inhabitant of moist, open woodlands and wetlands. **Distribution:** Breeds in the extreme south-eastern states of America and winters in South America. **Food:** Takes insects in flight, swooping down to snatch up reptiles and other small animals. Feeds while on the wing.

Nesting: Constructs a platform of twigs with a cup lined with Spanish Moss, usually high in a tree. 2–4 white eggs, heavily blotched with brown.

Pages 32-33
PLATE 14
BALD EAGLE (BIRD OF WASHINGTON or GREAT AMERICAN SEA EAGLE)

Haliaeetus leucocephalus. 29–38 inches (74–97cm). It favours broad river valleys, lake margins and seacoasts.

Distribution: Breeds in Canada, the western United States, the north-eastern states and east and Gulf coasts, wintering in the United States and on coasts. **Food:** Animals, but mainly fish and carrion. **Nesting:** In large, often re-used nests, on piles of sticks with a grass-lined cup. Usually nests near water, in a tree or on a rock ledge – rarely on the ground. 1–3 white eggs.

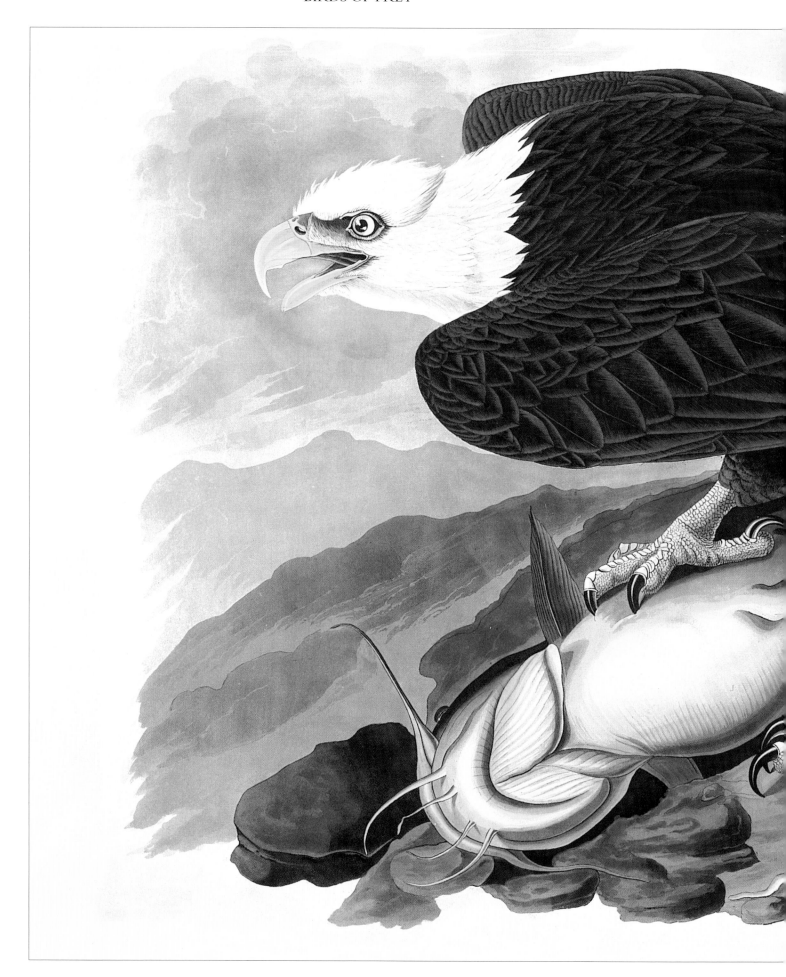

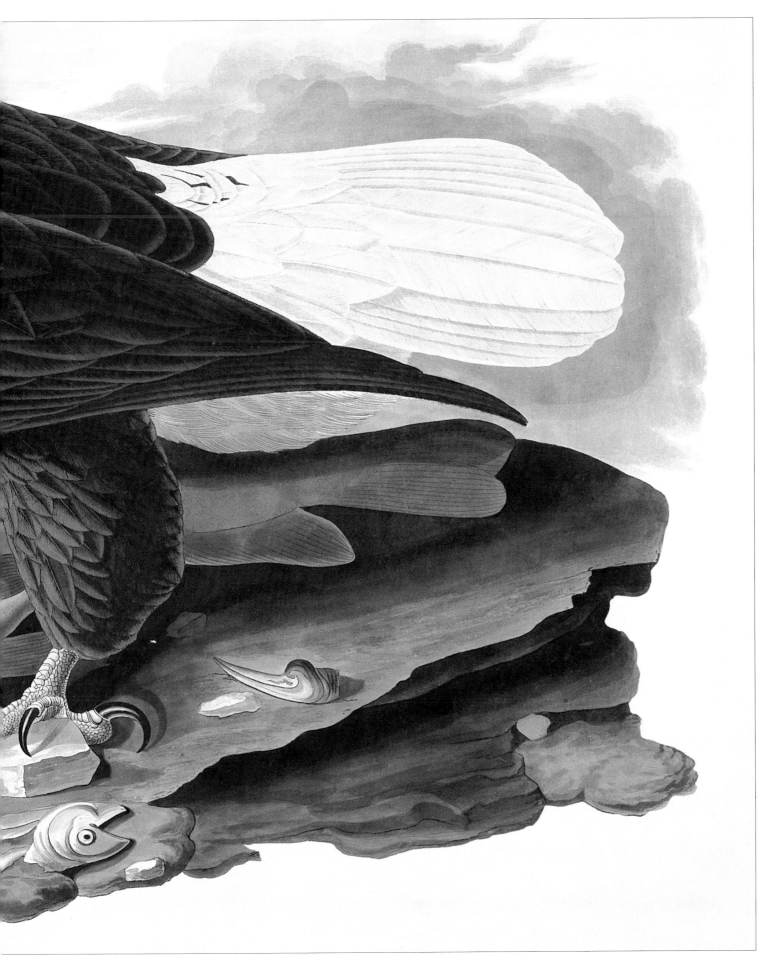

PLATE 15
MISSISSIPPI KITE

Ictinia mississippiensis. 15 inches (37cm). A gregarious species and an agile flier, it prefers open woodland, swamps and semi-arid areas. **Distribution:** Breeds in the central and south-eastern states of America, with stragglers elsewhere.

Overwinters in South America. **Food:** Takes insects in flight, snatching up small creatures, such as mice, from the ground. **Nesting:** On a variable mass of twigs, sometimes flimsy, it constructs a shallow cup in a tree, usually close to water. 1–3 bluish-white eggs.

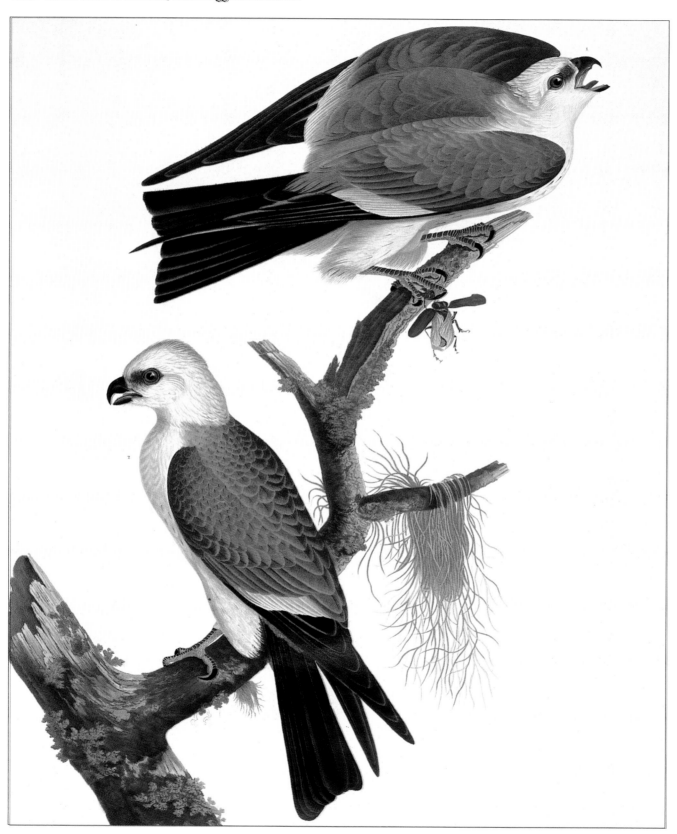

PLATE 15 ———— 34 ————

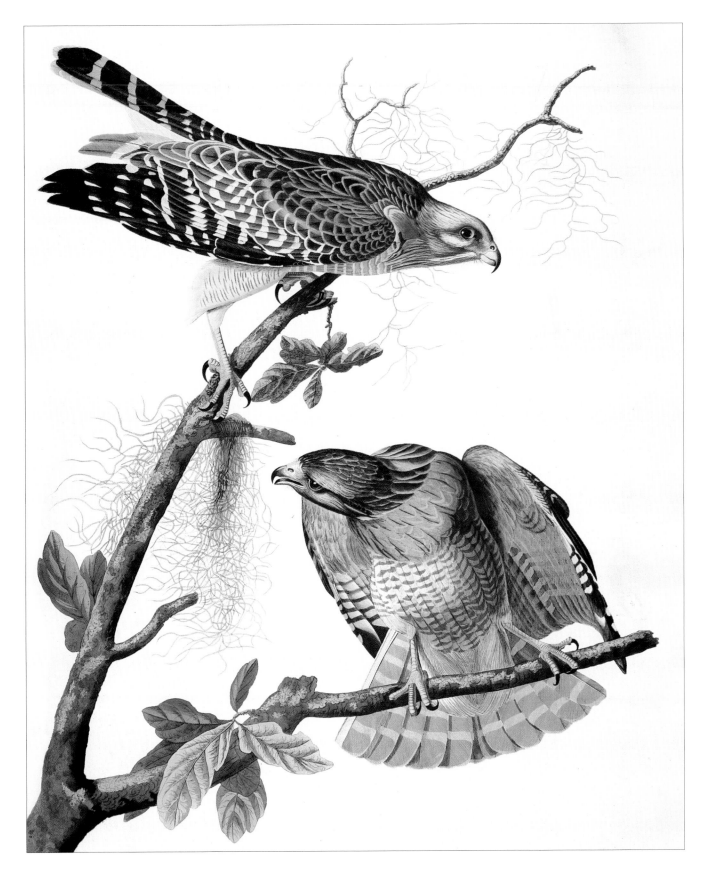

PLATE 16

RED-SHOULDERED HAWK

Buteo lineatus. 19 inches (48cm). Is seen most often near streams or rivers in areas of mixed woodland. **Distribution:** Breeds in the eastern half of the United States and in California, with some southward movement in winter from northern limits. **Food:** Various small animals. **Nesting:** Constructs bulky twig structures in trees which are lined with stems, leaves and bark. 2–3 white eggs, splashed with brown.

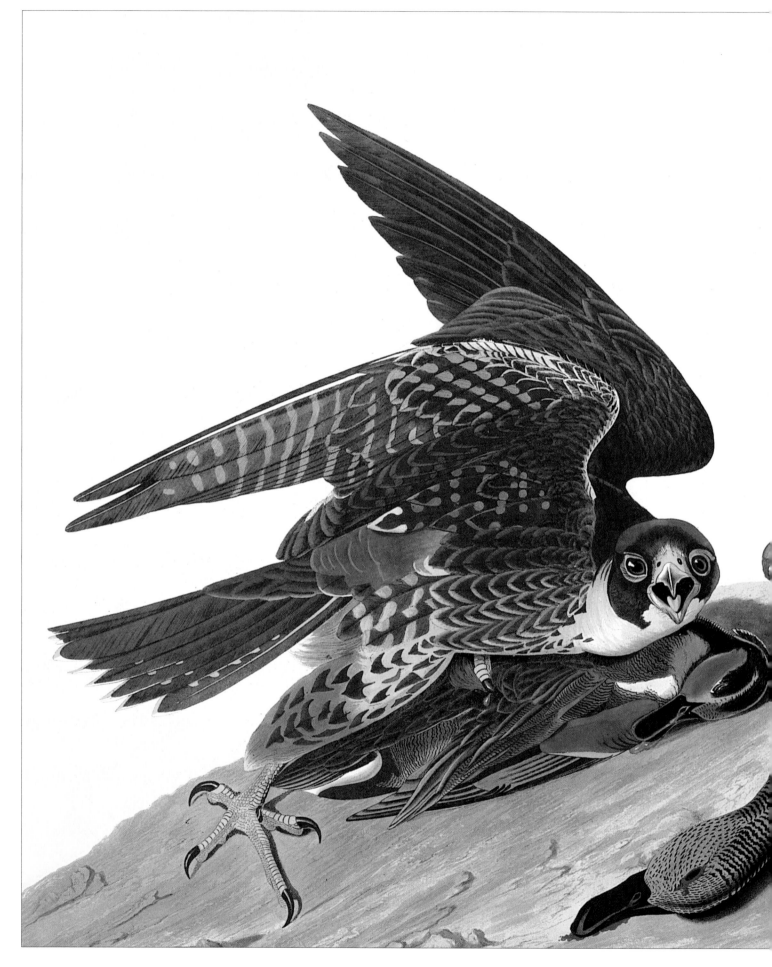

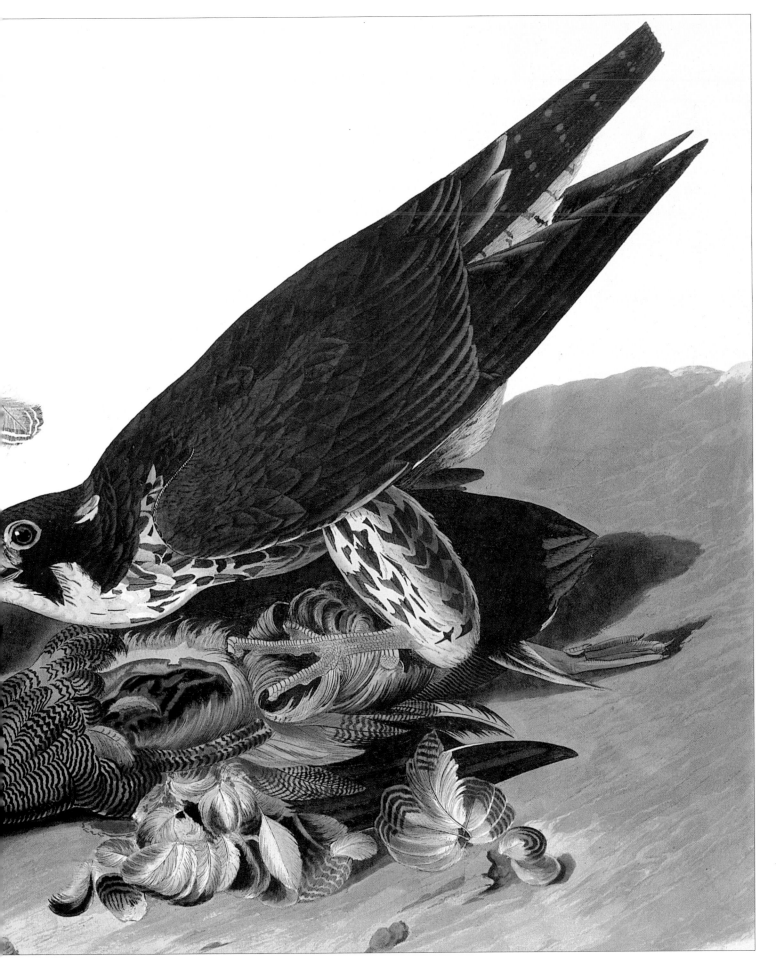

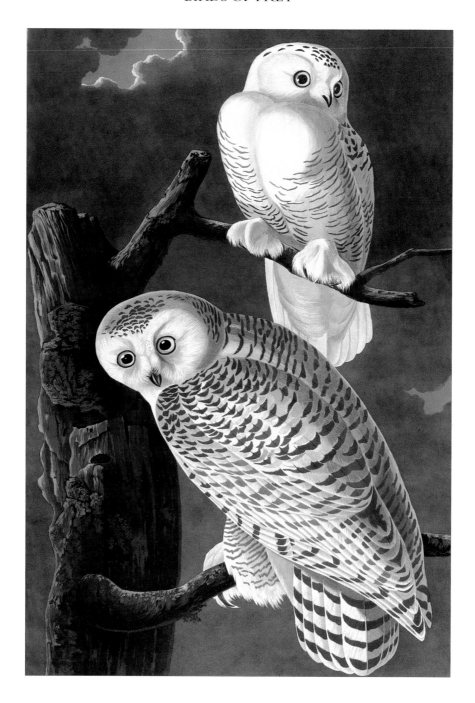

Pages 36-37

PLATE 17

GREAT-FOOTED HAWK (PEREGRINE FALCON)

Falco peregrinus. 16–20 inches (41–51cm). A fast-hunting bird of open country, usually near cliffs or rocky outcrops, sometimes in cities. **Distribution:** Breeds in Alaska, northern Canada, and locally in western and eastern regions of the United States. Wintering birds leave Canada, appearing on east and Gulf coasts and California. **Food:** Mainly birds such as duck and pigeons, occasionally mammals. **Nesting:** A bare scrape, usually on a rocky ledge. 3–4 cream to buff eggs, marked with brown.

PLATE 18 above

SNOWY OWL

Nyctea scandiaca. 23 inches (58cm). A large day-hunting white owl of open tundra, it is a winter vagrant and perches conspicuously in open spaces. **Distribution:** Resident on northern tundra, wandering as far as the northern United States in winter. **Food:** Lemmings, and a wide range of other creatures. **Nesting:** In an unlined shallow hollow on a slightly raised site in the open. 4–10 white eggs.

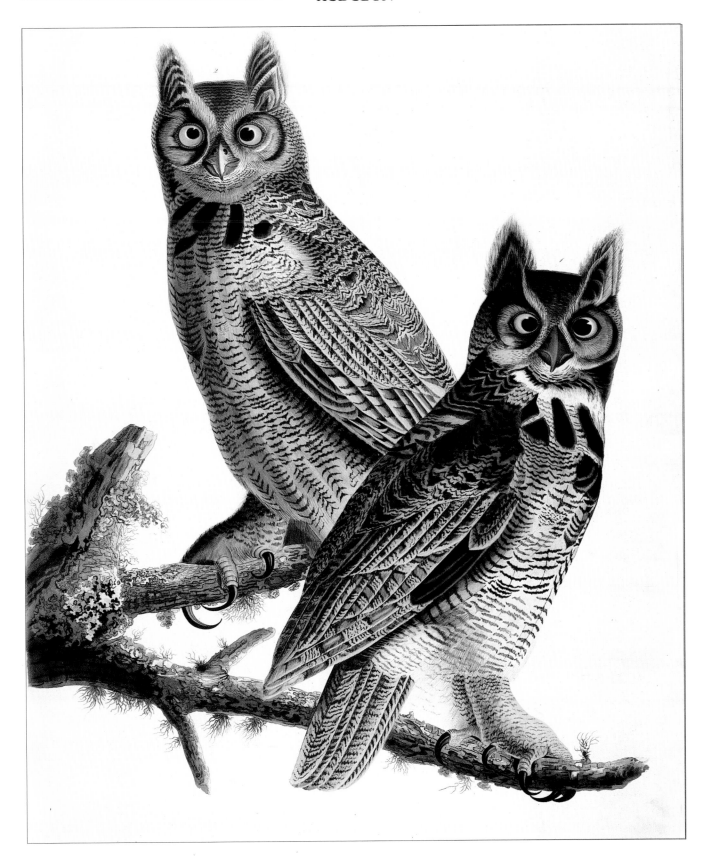

PLATE 19

GREAT HORNED OWL

Bubo virginianus. 22 inches (56cm). A large owl with prominent ear tufts and a white throat, it can be seen in all types of habitats. However, it is mainly nocturnal and hides by day. **Distribution:** Resident over North America.

Food: Live creatures, from insects to grouse and rabbits.

Nesting: Eggs are laid in a large cavity or recess, in trees, rocks or on the ground, or in large old nests of other bird species.

PLATE 20

RED-THROATED DIVER (RED-THROATED LOON

Gavia stellata. 25 inches (64cm). Resident along smaller lakes and pools. **Distribution:** On tundra of northern Canada and Alaska, it overwinters on east and west coasts and along the shores of the Great Lakes. **Food:** Mainly fish, also frogs and invertebrates. **Nesting:** In a hollow on a low mound of vegetation at the water's edge. 2 olive to brown black-spotted eggs. *Figs. 1 Male adult in summer plumage, 2 In winter plumage, 3 Adult female, 4 Young.*

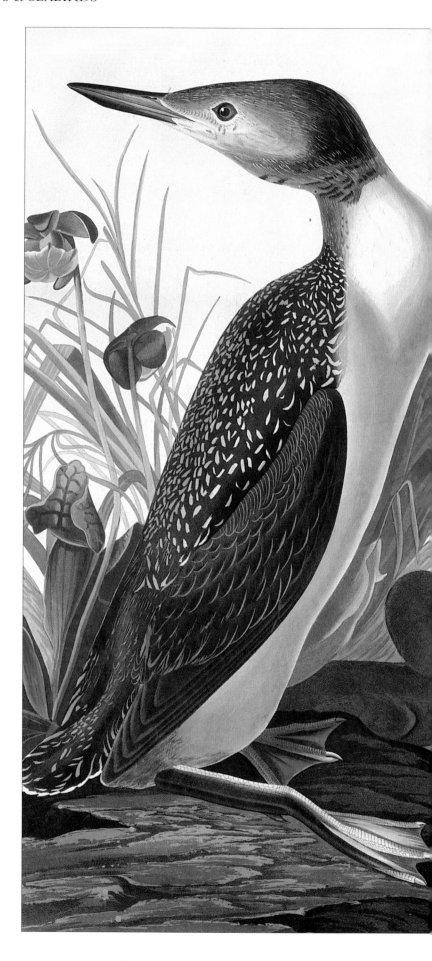

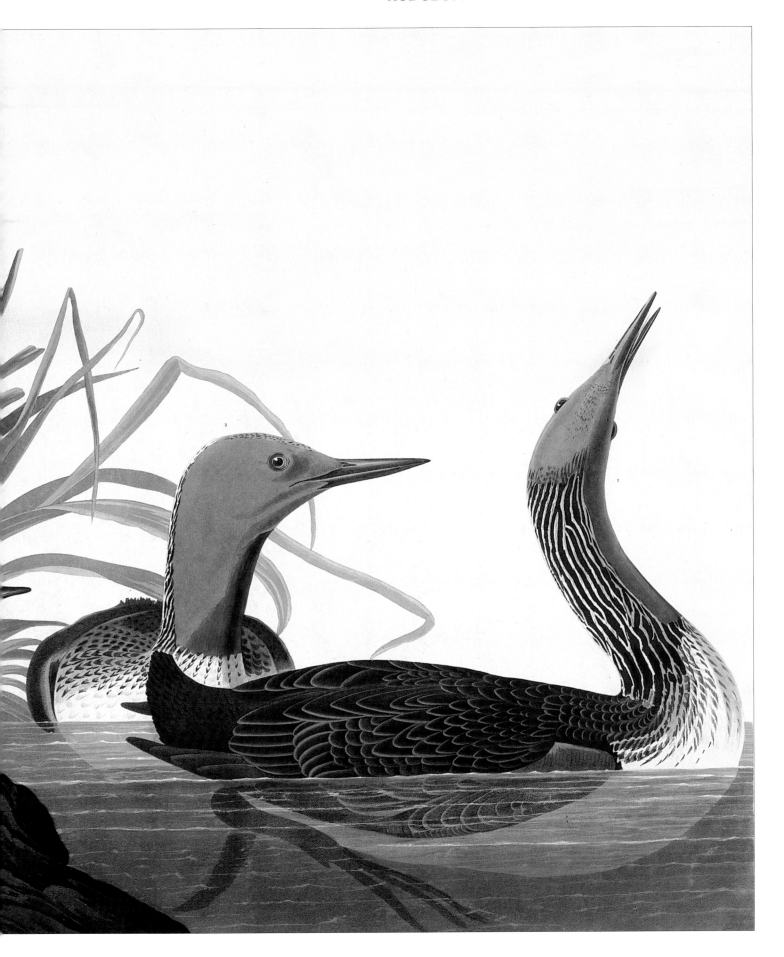

PLATE 21
BUFF-BREASTED SANDPIPER

Tryngites subruficollis. 8 inches (21cm). A shorebird of dry grassy tundra, short grass and areas of grassy cultivation and ricefields. **Distribution:** Breeds on tundra coasts and islands of north-western North America, wintering in South America. **Food:** Small invertebrates. **Nesting:** In a shallow scrape with sparse grassy linings on dry tundra. 4 cream to olive eggs with dark spotting and blotches. *Figs. 1 Male, 2 Female*.

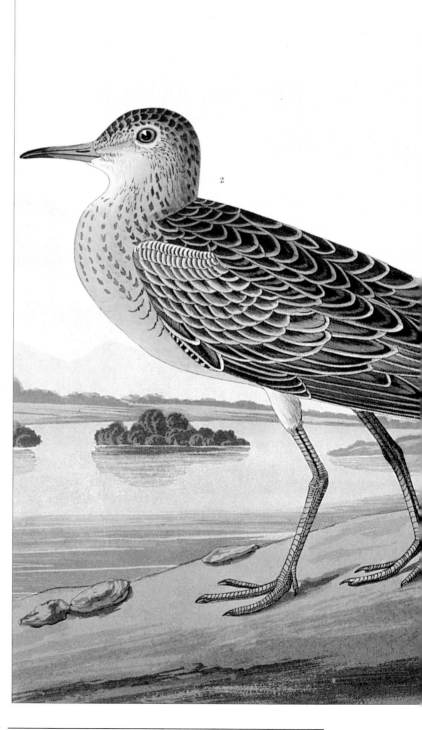

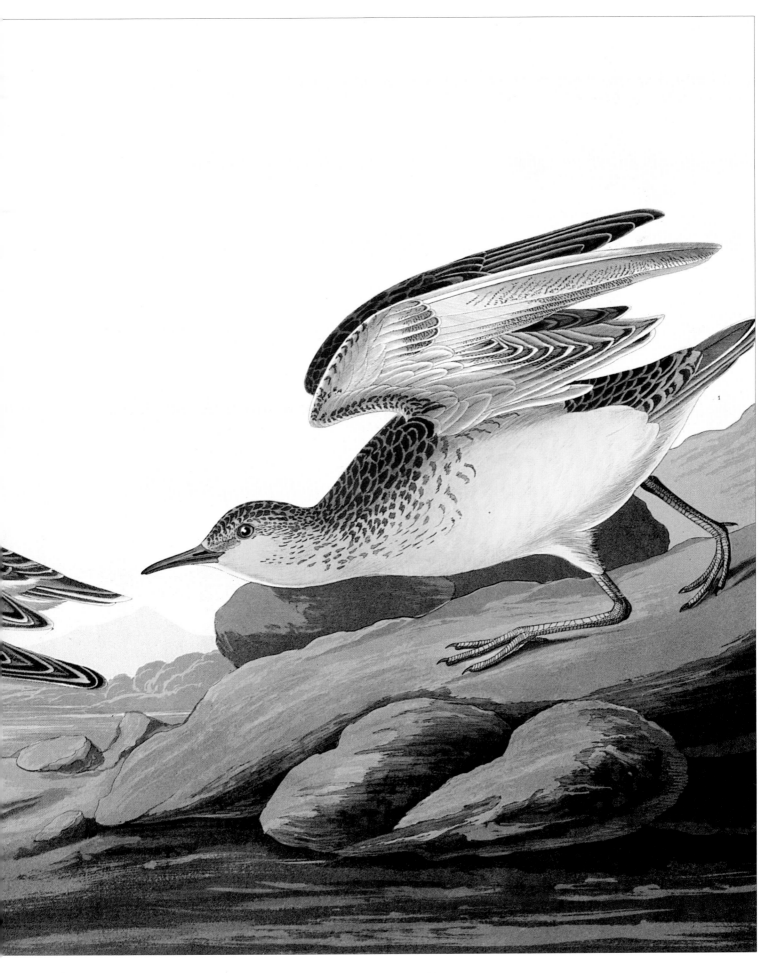

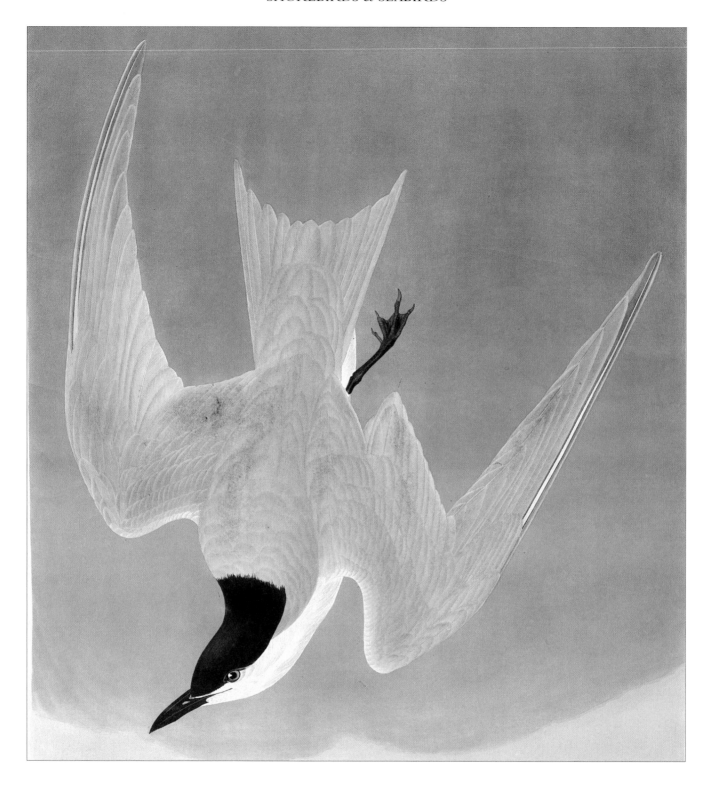

PLATE 22 above
MARSH TERN (GULL-BILLED TERN)

Sterna nilotica. 14 inches (36cm). A short-billed tern of open fields and marshes, bare dry shorelines, saltmarshes and beaches. **Distribution:** Breeds on east and Gulf coasts, overwintering from the Gulf of Mexico to South America. **Food:** Insects taken in flight and small invertebrates of land and water. **Nesting:** In sparsely-lined hollows on open sites near water. 3 creamy-buff eggs with variable dark markings.

PLATE 23 opposite
ROSEATE TERN

Sterna dougallii. 15 inches (39cm). A sea tern, it nests on coastal sands and shingle, and on small rocky islands. **Distribution:** Breeds in the north-east, from Nova Scotia to New England, wintering in South America. **Food:** Plunge-dives for fish and other creatures. **Nesting:** In colonies, sometimes with other tern species in a shallow scrape. 1–3 eggs, variably tinted and patterned.

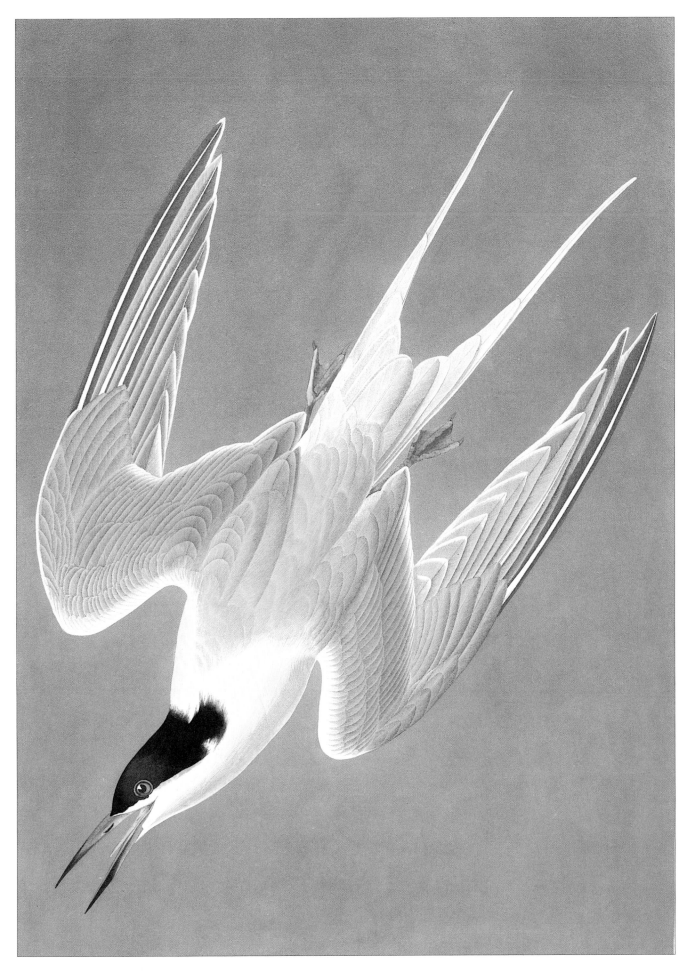

PLATE 24
HUDSONIAN GODWIT

Limosa haemastica. 15 inches (39cm). Breeds in sedgy marshland along tree-bordered rivers and coasts, and on estuaries, ricefields, and grassland. **Distribution:** Breeding occurs in central Alaska and in northern Canada and the Hudson Bay area. It winters in South America. **Food:** Invertebrates. **Nesting:** In hollows on a dry site in wet areas. 3–4 olive or green eggs with dark markings. *Figs. 1 Male, 2 Young female in summer plumage.*

Page 48
PLATE 25
LESSER TERN (LEAST TERN)

Sterna antillarum. 9 inches (23cm). On beaches and sandbars of coasts and large rivers. **Distribution:** Breeds on the Gulf coasts, the east coast, central rivers of the United States and in southern California, overwintering on the Gulf of Mexico and the Caribbean. **Food:** Plunge-dives for fish and small creatures. **Nesting:** In a colony of shallow scrapes in the open. 2–3 cream to buff eggs, darkly speckled.

Page 49
PLATE 26
HERRING GULL

Larus argentatus. 25 inches (64cm). A scavenger and general feeder, its spread is from coasts and inland waters to farmlands and cities. **Distribution:** Breeds across Canada, except the south-west, and is resident in the north-eastern states of America and on east and west coasts. **Food:** Carrion, small creatures, seeds and fruit. **Nesting:** Constructs a bulky cup of plant debris on the ground or on rocks, buildings or in conifers. 2–3 green to brownish eggs, variably marked.

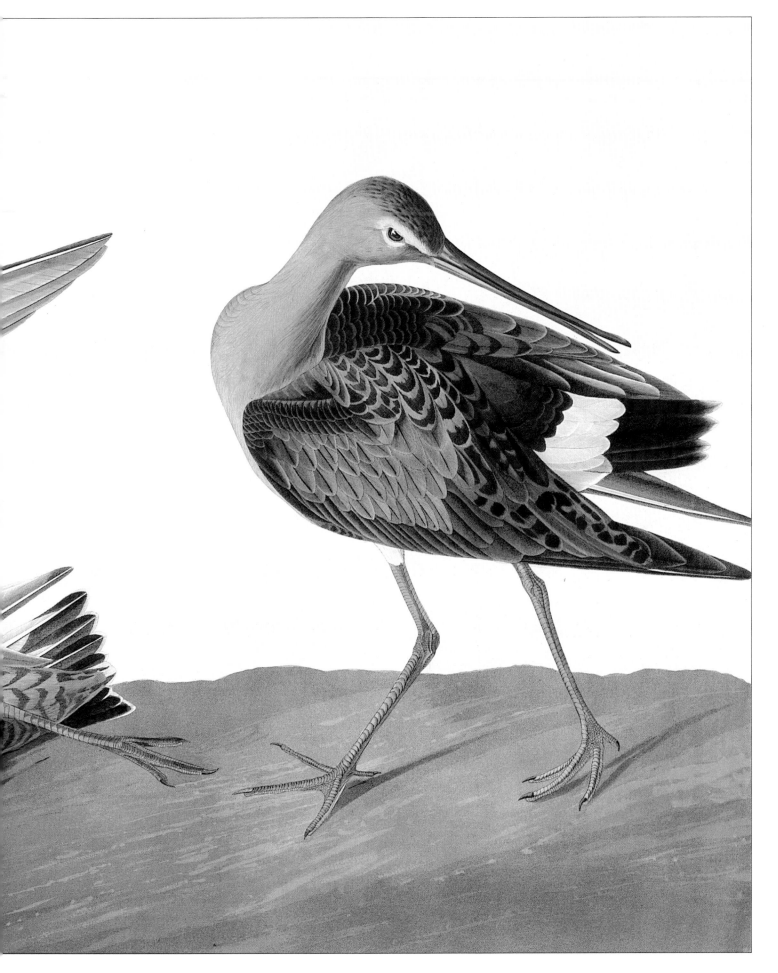

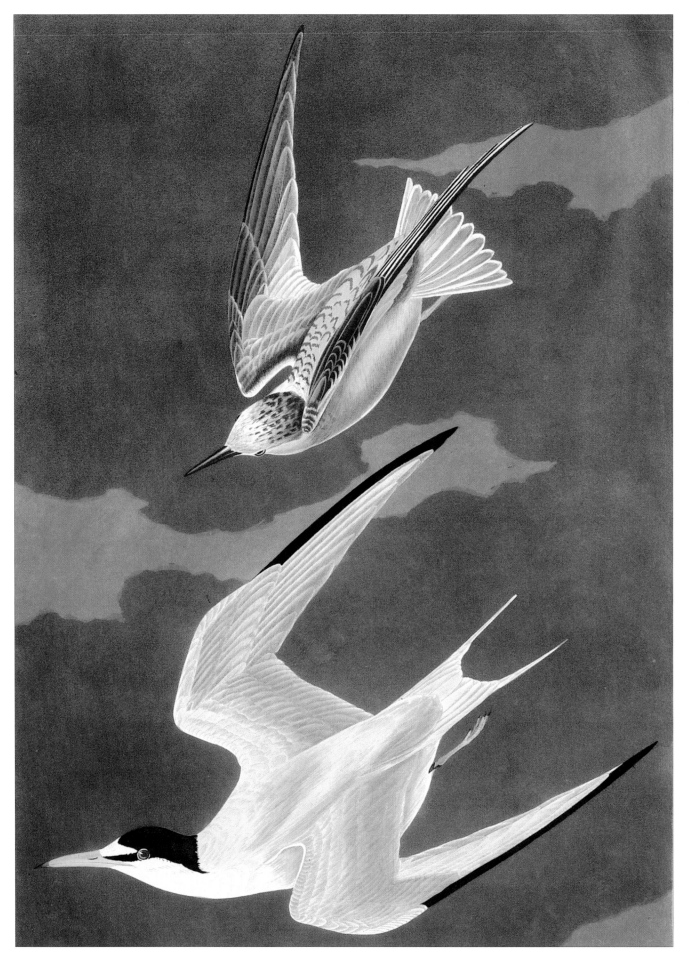

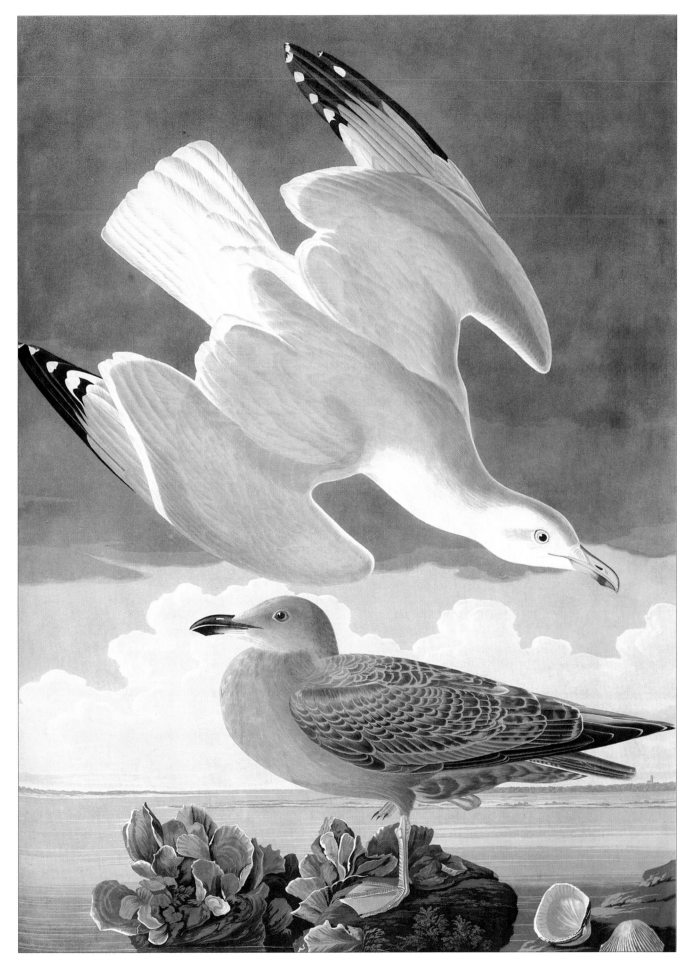

PLATE 27

SEMIPALMATED SANDPIPER

Calidris pusilla. 6 inches (16cm). Occurs on wet tundra, usually near open water, and on the tidal mud of estuaries and shorelines. **Distribution:** Breeds on the tundra of northern Alaska and Canada, wintering around the Gulf of Mexico and the Caribbean. **Food:** Small invertebrates. **Nesting:** In a plant-lined shallow hollow, hidden in herbage. 4 olive or greenish eggs with dark markings.

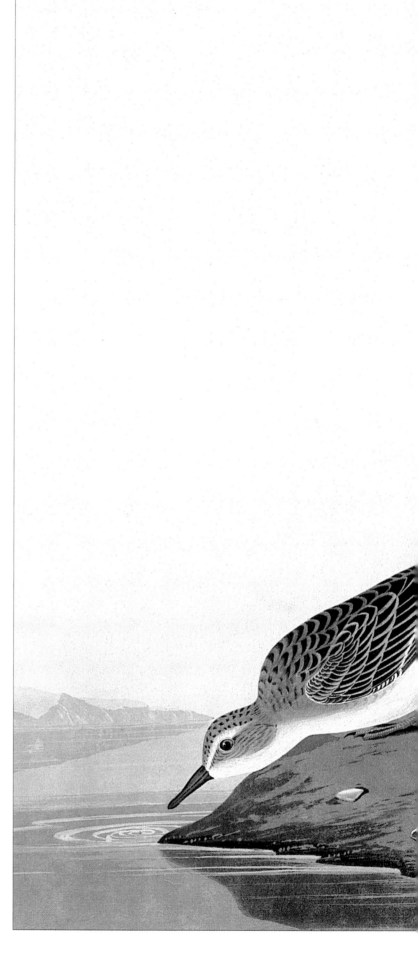

Pages 52-53

PLATE 28

PIPING PLOVER

Charadrius melodus. 7 inches (18cm). A pale plover found on sandy beaches, lake shores and dunes. **Distribution:** Breeds in southern and south-eastern Canada, the central plains, the Great Lakes and east and south coasts of the United States. It resides south of the Carolinas, wintering on the Gulf of Mexico. **Food:** Small invertebrates. **Nesting:** In a shallow scrape in sand. 4 cream to buff eggs, with dark speckling. *Figs.1 Male, 2 Female.*

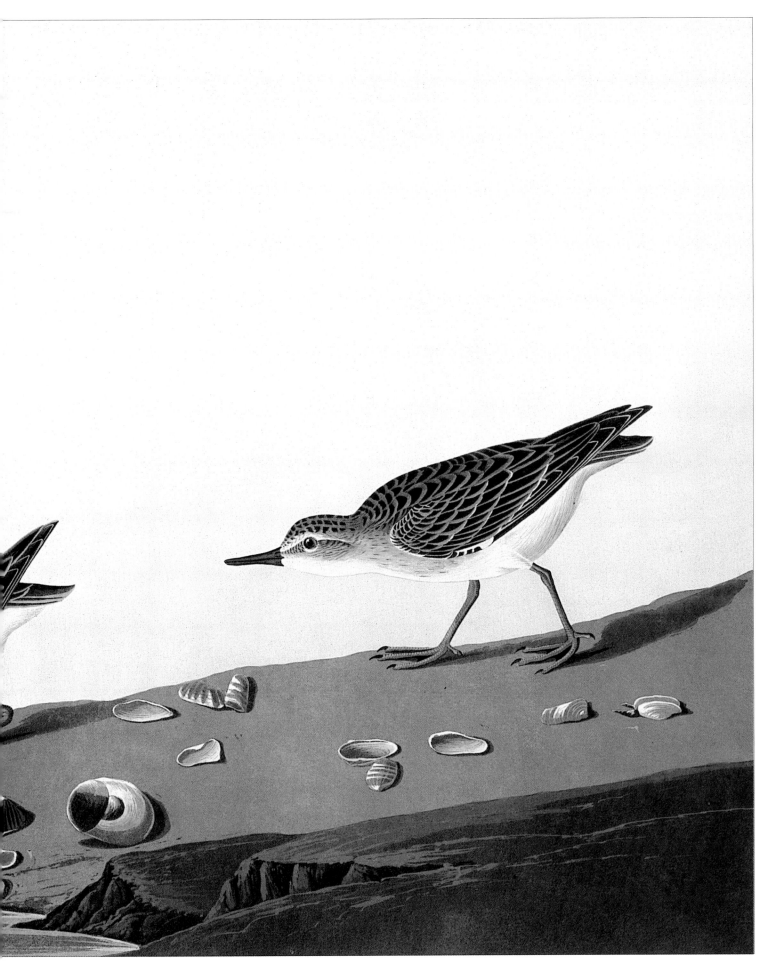

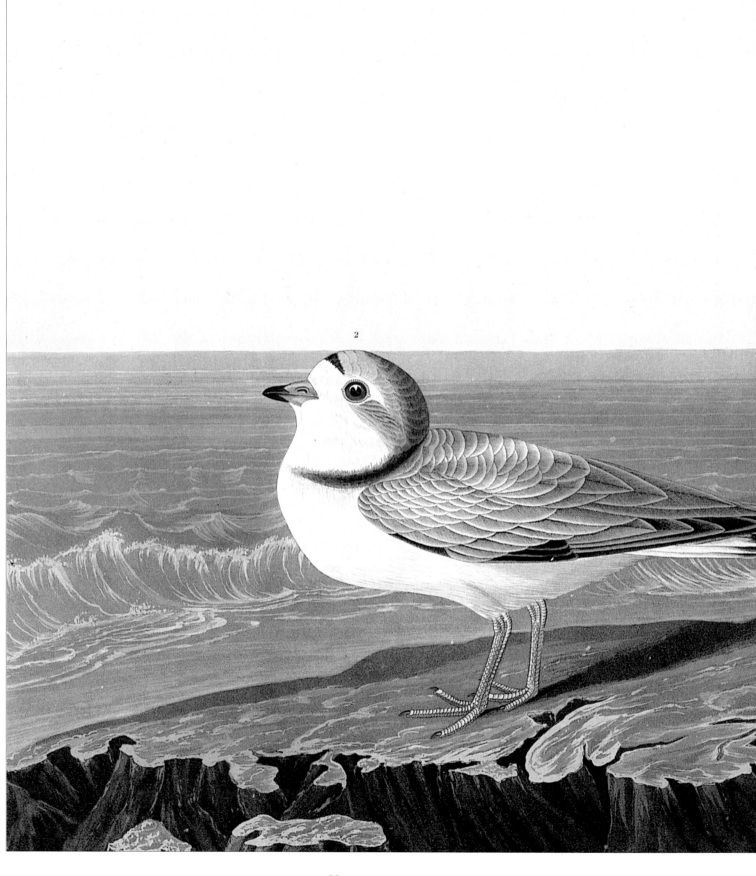

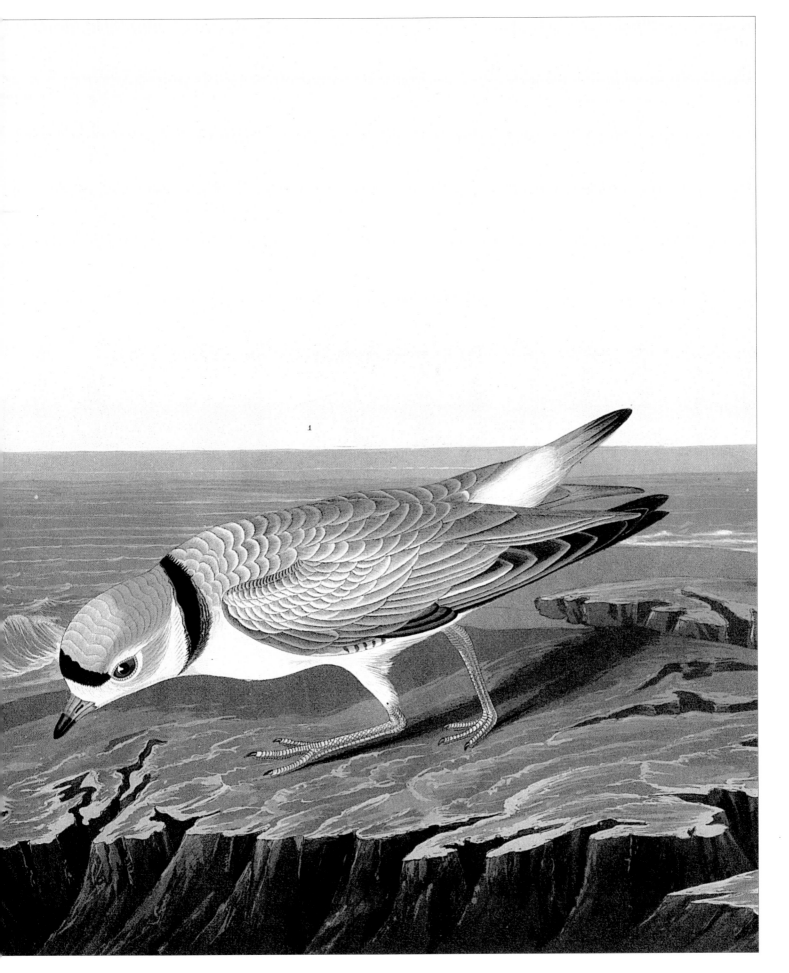

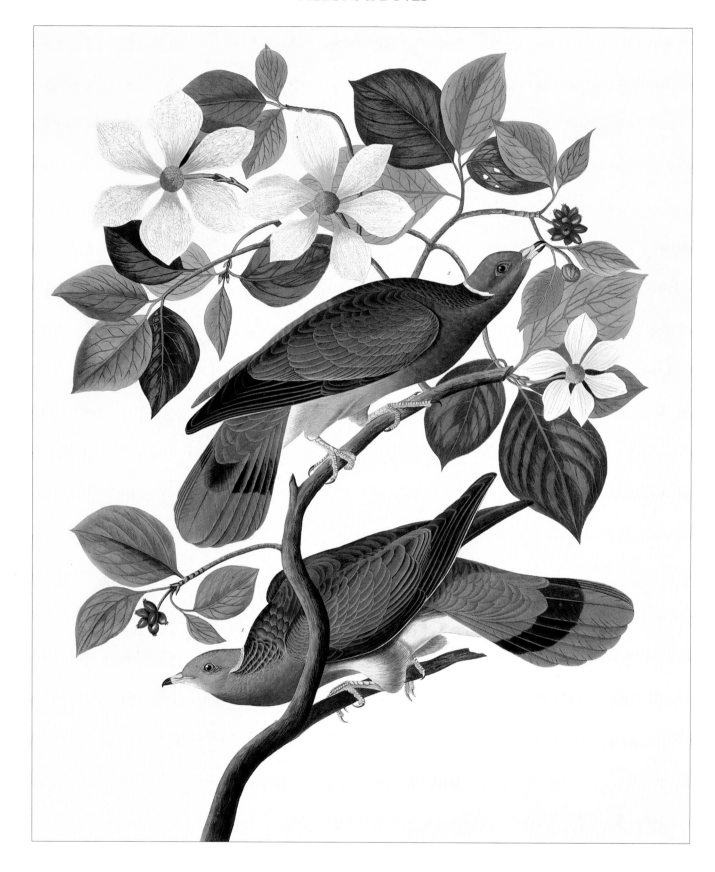

PLATE 29

BAND-TAILED PIGEON

Columba fasciata. 15 inches (37cm). A montane woodland pigeon, it inhabits conifer, pine-oak and oak woodland, chapparal and gardens. **Distribution:** Breeds from British Columbia to California and the southern Rockies, wintering from south of the range to Central America. **Food:** Seeds, buds, leaves, blossoms and berries. **Nesting:** On a twig platform in trees or shrubs. One white egg. *Figs.1 Male, 2 Female.*

PLATE 30

PASSENGER PIGEON

Ectopistes migratorius. In all probability it is now extinct. Like the bigger, brighter Mourning Doves, its habit was to rove in flocks miles long, nesting in gigantic colonies. Sadly, the species was exterminated for food and sport by 1914. **Distribution:** In forests in the eastern states of America. **Food:** Nuts, acorns and seeds. **Nesting:** In nests on twig platforms in trees, almost touching one another. 2 white eggs. *Figs. 1 Male, 2 Female.*

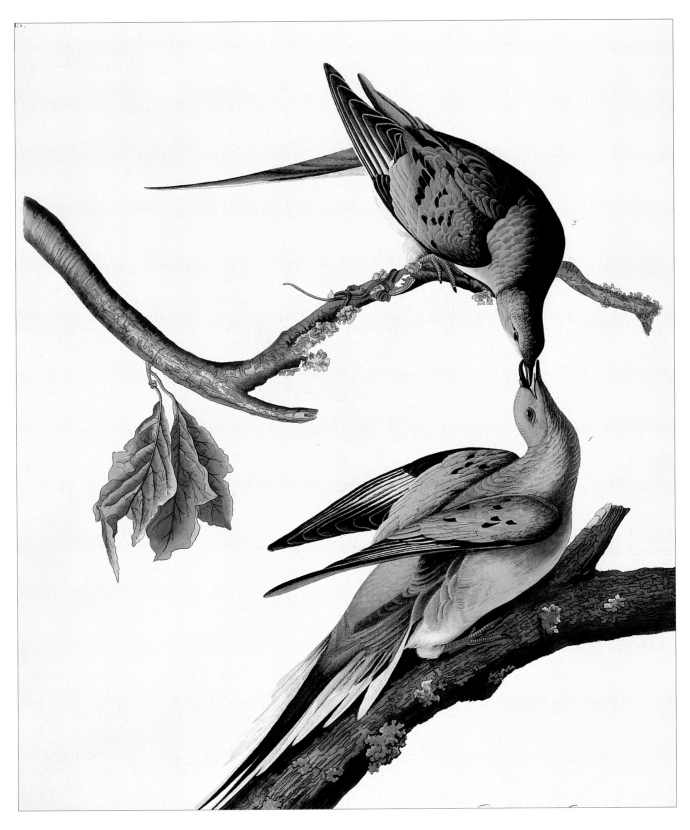

PLATE 31
KEY WEST DOVE
(KEY WEST QUAIL DOVE)

Geotrygon chrysia. 12 inches (31cm). Ground-feeding dove of forest undergrowth and scrub. **Distribution:** The Greater Antilles, but an accidental visitor to the Florida Keys. **Food:** Seeds, fruit and small invertebrates. **Nesting:** On twig platforms with some leaves, situated low in a tree or shrub or on the ground. 2 buff or buffish-brown eggs.

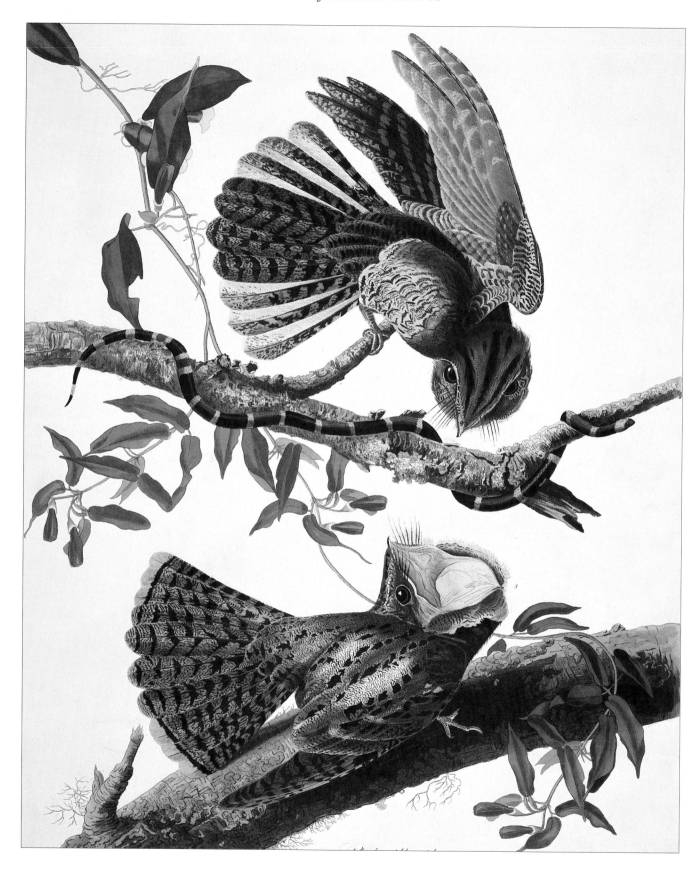

PLATE 32

CHUCK-WILL'S-WIDOW

Caprimulgus carolinensis. 12 inches (31cm). A large nightjar with a loud whistling call, it lives in mixed oak woodland and live oak groves. **Distribution:** Breeds in the south-eastern United States, is resident in Florida and on the Gulf coast, overwintering in Central America. **Food:** Large insects and at times very small birds. **Nesting:** 2 pale eggs, mottled and blotched grey and purple are laid on the ground beneath trees, on a bed of dead leaves and pine needles.

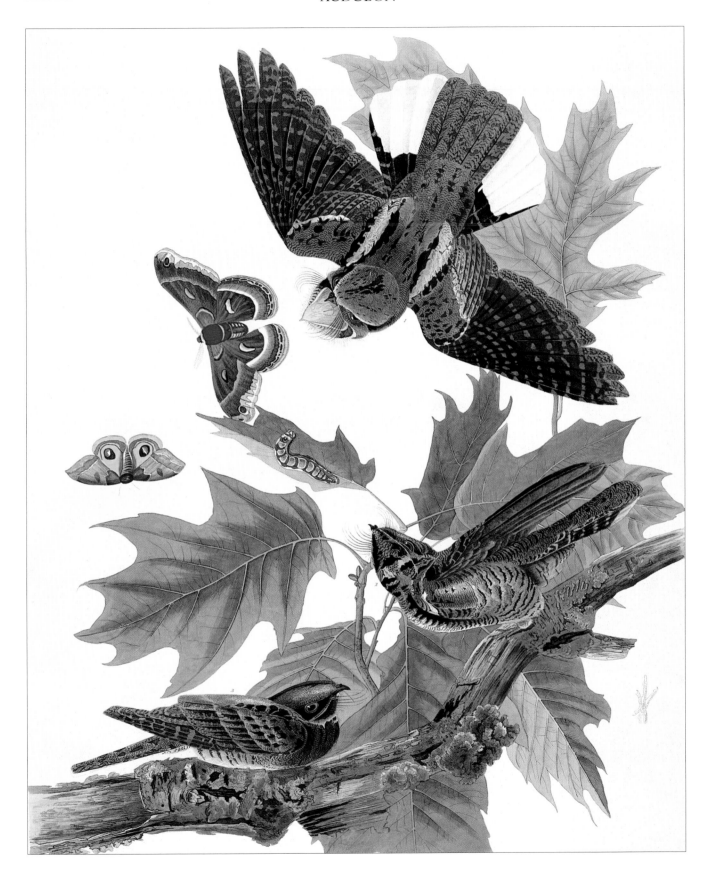

PLATE 33
WHIP-POOR-WILL

Caprimulgus vociferus. 10 inches (25cm). Nocturnal and inconspicuous but with a well-known call, it inhabits open conifer and broadleaf woodland, and wooded canyons.

Distribution: Breeds in south-eastern Canada and the eastern and south-western United States, overwintering in Florida, on the Gulf coast, and in Central America. **Food:** Insects caught in flight. **Nesting:** 2 white eggs with dark spots and blotches are laid on the ground on a bed of dead leaves.

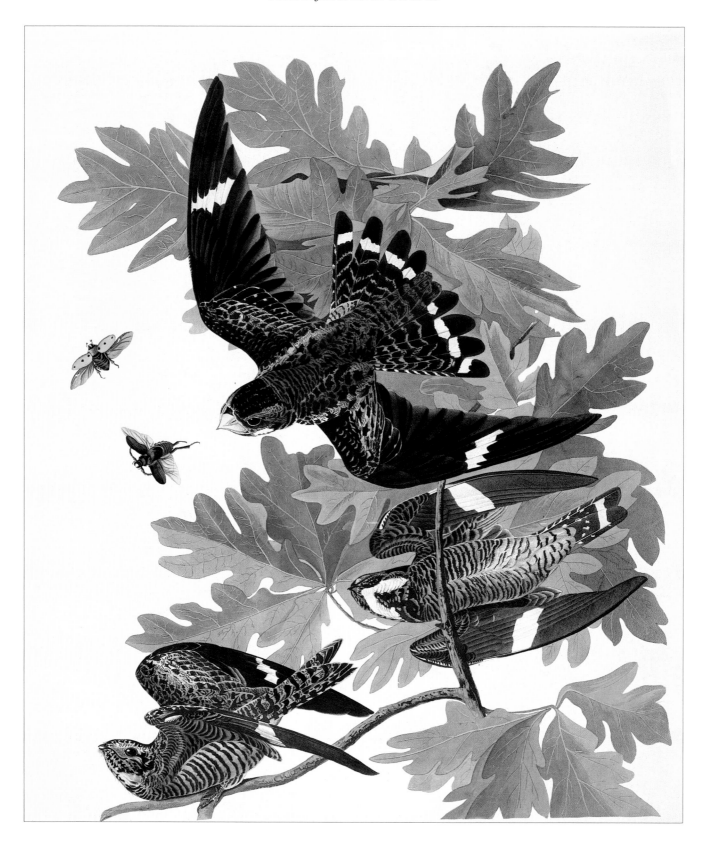

PLATE 34

COMMON NIGHTHAWK

Chordeiles minor. 9 inches (24cm). Slender and long-winged, this nightjar hunts actively by day. It is an inhabitant of open, sandy or gravelly, rocky places on shores, in areas of cultivation and clearings. It also roosts and nests on flat roofs. **Distribution:** Breeds over North America, winters in South America. **Food:** Insects caught in flight. **Nesting:** 2 creamy-white eggs, finely marked or mottled grey and brown are laid on bare ground.

PLATE 35
BARN SWALLOW

Hirundo rustica. 7 inches (17cm). Can be found in open country and around areas of human habitation.
Distribution: Breeds throughout North America, wintering in Central and South America. **Food:** Insects caught in flight. **Nesting:** A mud-pellet cup lined with feathers, and built in a cave, building, shed or under a bridge. 4–5 white eggs with variable spotting. *Figs. 1 Male, 2 Female.*

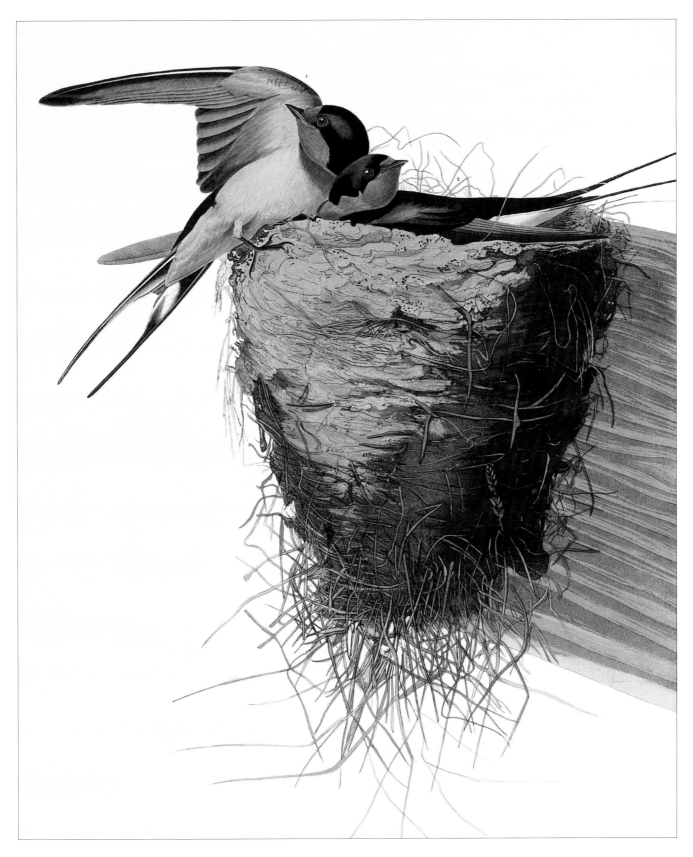

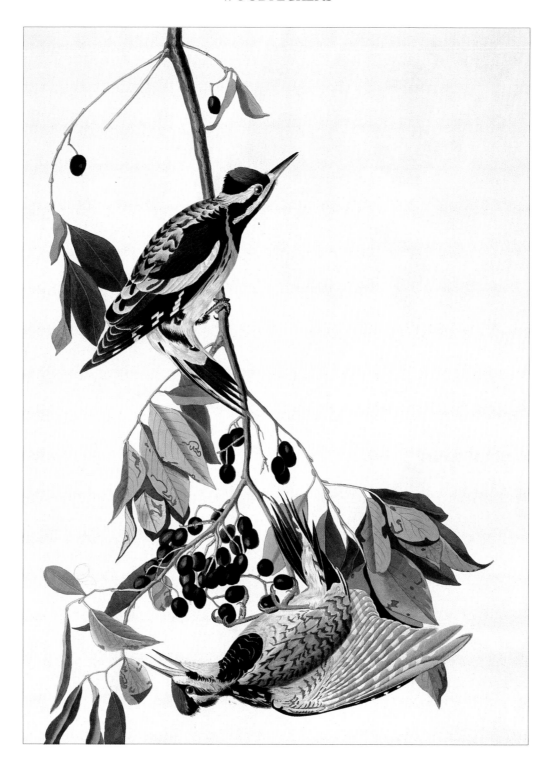

PLATE 36 above
YELLOW-BELLIED WOODPECKER (YELLOW-BELLIED SAPSUCKER)

Sphyrapicus varius. 9 inches (22cm). Widespread, and typically found in broadleaf trees of mixed or broadleaf woodland. **Distribution:** Breeds in Canada and the north-eastern United States, wintering in the southern states. **Food:** Systematically drills tree-trunks for sap to drink, and feeds on insects. **Nesting:** In a cavity bored in a tree-trunk. 5–6 white eggs. *Figs. 1 Male, 2 Female.*

PLATE 37 opposite
IVORY-BILLED WOODPECKER

Campephilus principalis. 20 inches (50cm). This is a large, conspicuously patterned woodpecker and requires mature river forests with dead or dying trees as its habitat. **Distribution:** It was resident in the southern swamplands of the United States, where it is now possibly extinct. A few of a local subspecies may survive in Cuba. **Food:** Wood-boring grubs or insects. **Nesting:** In large cavities bored in old tall trees. 1–4 white eggs. *Figs. 1 Male, 2, 3 Females.*

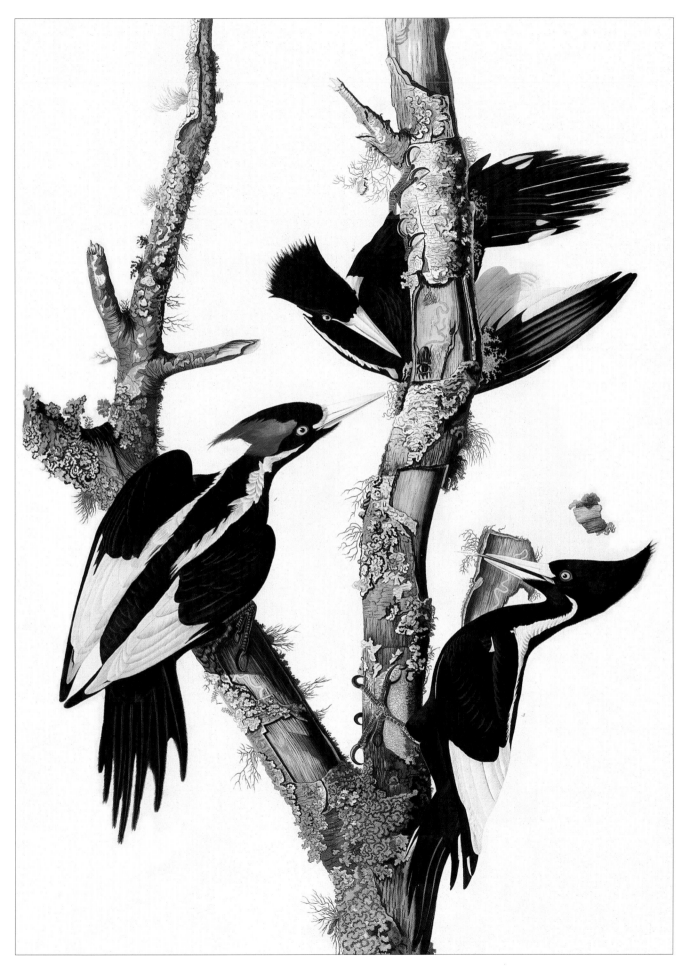

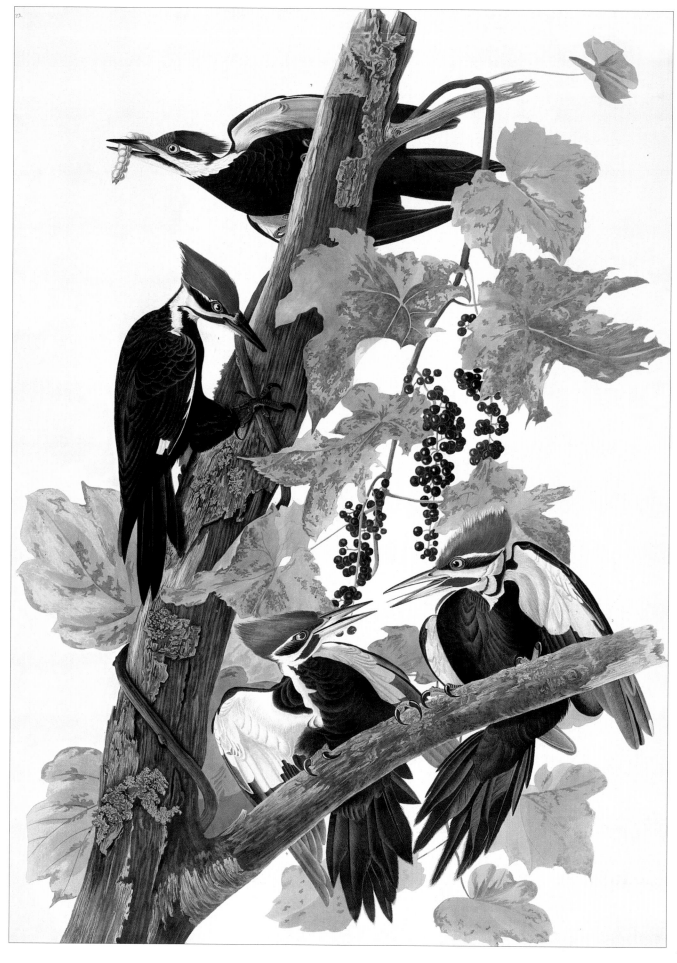

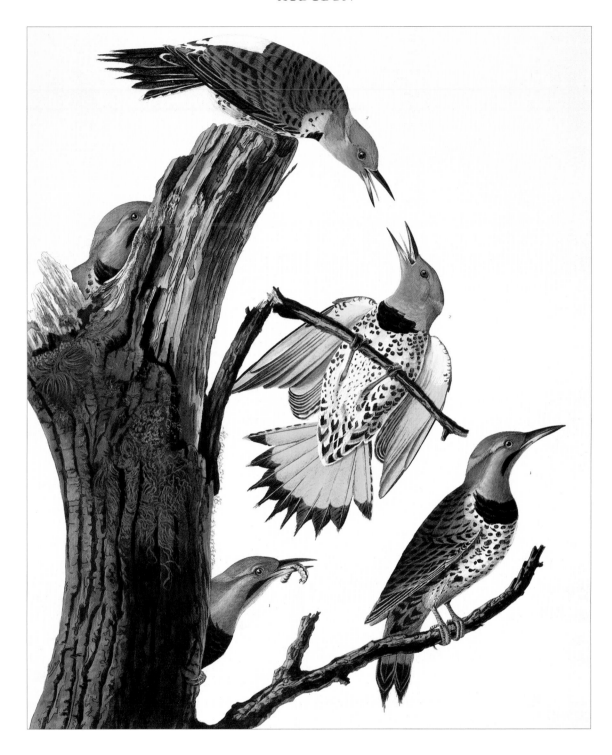

PLATE 38 opposite
PILEATED WOODPECKER

Dryocopus pileatus. 17 inches (42cm). The most widespread woodpecker in North America, it favours dense, mature woodland, areas of secondary growth and smaller woodlands. **Distribution:** Resident in southern Canada and eastern and north-western United States. **Food:** Large wood-boring grubs. **Nesting:** In a large unlined cavity bored into dead wood or a tree or post. 3–5 white eggs. *Figs. 1 Adult male, 2 Adult female, 3, 4 Young males.*

PLATE 39 above
GOLD-WINGED WOODPECKER (NORTHERN FLICKER)

Colaptes auratus. 13 inches (32cm). An ant-feeding woodpecker of open grassy areas, farmland and open spaces where there are scattered trees; also in open woodland and suburbs. **Distribution:** Resident in the United States and a summer breeder in Canada. **Food:** Ants and other invertebrates. **Nesting:** In a cavity bored in a tree-trunk or post, or the bird may use a nest box. 6–8 white eggs. *Figs. 1 Males, 2 Females.*

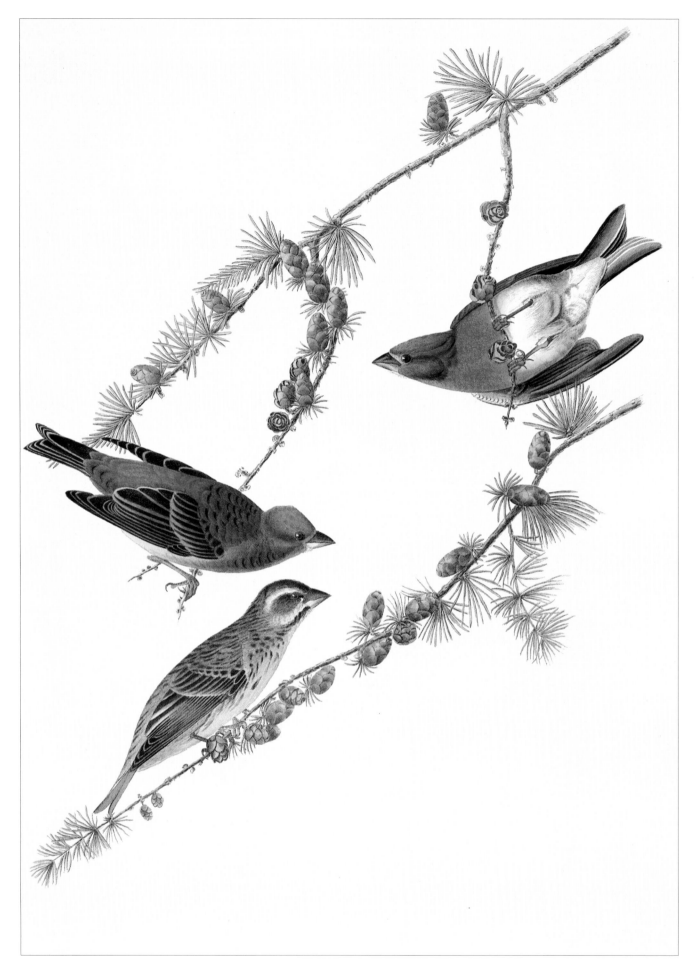

PLATE 40 opposite
PURPLE FINCH

Carpodacus purpureus. 6 inches (15cm). An inhabitant of open conifer and broadleaf woodland, parkland and garden. **Distribution:** Breeds in Canada, the north-eastern and western United States, leaving Canada to winter in eastern and far-western American states. **Food:** Seeds, buds, fruits. **Nesting:** In a cup in a tree, preferably a conifer. 4–5 light-blue eggs, with sparse dark spots and scrawls.

PLATE 41 right
BLUE YELLOW-BACK WARBLER (NORTHERN PARULA WARBLER)

Parula americana. 4 inches (11cm). Lives in conifer and mixed woodland, often by water. **Distribution:** Breeds in eastern North America, winters in Florida and Central America. **Food:** Small invertebrates. **Nesting:** In cup-like structures, often built into hanging tree lichen or Spanish Moss. 3–5 white eggs, with dark markings.

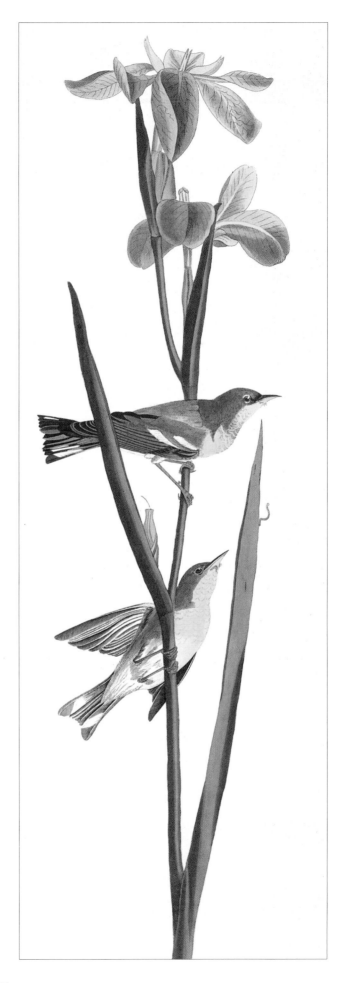

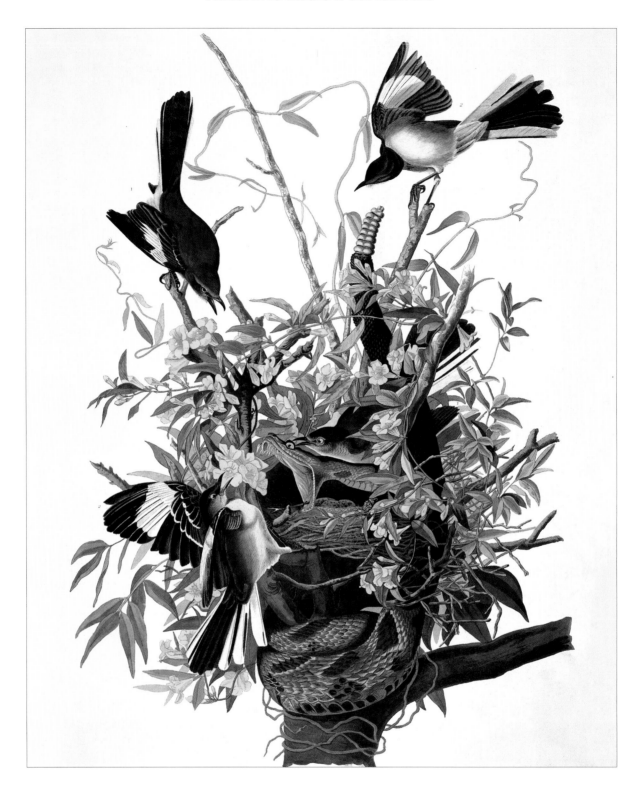

PLATE 42 above
MOCKING BIRD (NORTHERN MOCKING BIRD)

Mimus polyglottos. 10 inches (25cm). **Distribution:** A conspicuous songbird of the United States, apart from the northwest; it winters in the southern states and in Mexico. **Food:** Invertebrates, fruit. **Nesting:** In a bulky cup in small thickets. 3–5 bluish eggs with reddish markings. *Figs. 1 Males, 2 Females.*

PLATE 43 opposite
CEDAR BIRD (CEDAR WAXWING)

Bombycilla cedrorum. 7 inches (18cm). Gregarious and sociable, it inhabits open woodland, scrub, orchards and areas of scattered trees. **Distribution:** Breeds from southern Canada to the mid United States, wintering in the central and southern states and Central America. **Food:** Fruit, insects. **Nesting:** In a bulky twig cup with finer linings. 3–5 pale-blue eggs with sparse dark spots. *Figs. 1 Male, 2 Female.*

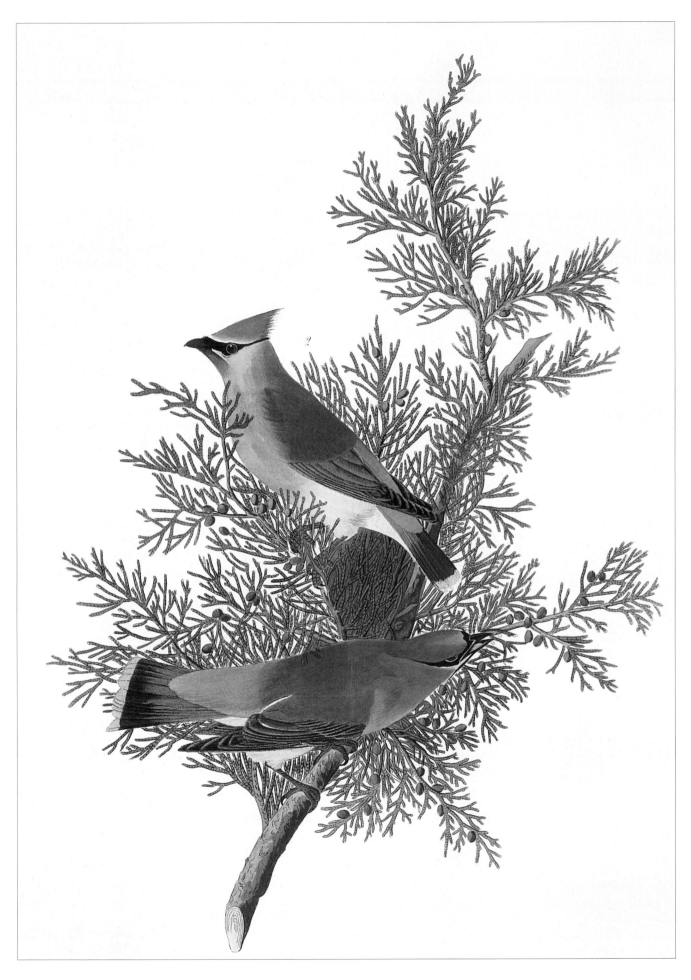

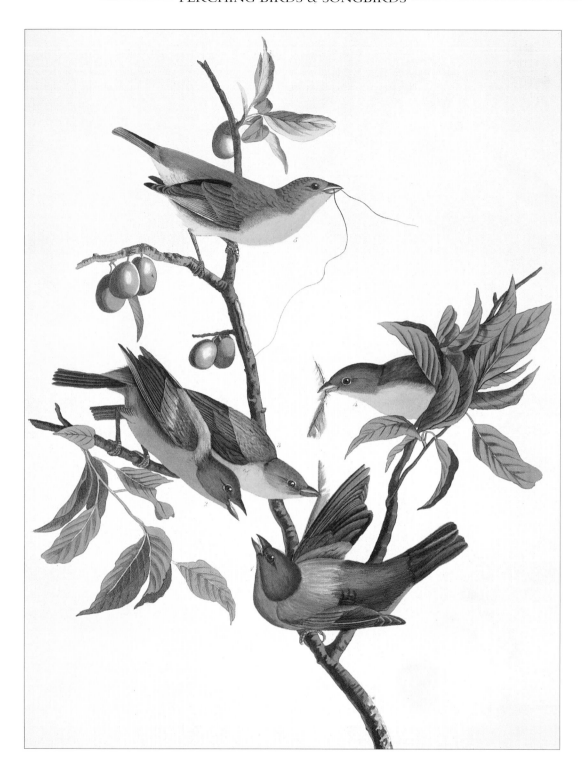

PLATE 44 above
PAINTED BUNTING

Passerina ciris. 6 inches (14cm). Prefers low shrubby growth, streamside thickets, and areas of tall herbage. **Distribution:** Breeds from New Mexico to Tennessee, from the Carolinas to Florida, wintering from Central America to the Bahamas. **Food:** Seeds, fruit, insects. **Nesting:** In a neat, deep cup, partly woven to supports, in bushes, vines or Spanish Moss. 3–4 white eggs with reddish speckling. *Figs. 1 & 2 Old males, 3 & 4 1st- and 2nd-year males, 5 Female.*

PLATE 45 opposite
OLIVE-SIDED FLYCATCHER (BOREAL PEWEE)

Cantopus borealis. 7 inches (19cm). Often solitary, with a loud, three-note song, this is a bird mainly of conifer woodland. **Distribution:** Breeds in northern North America and winters in South America. **Food:** Mainly flying insects, some berries. **Nesting:** In a cup of lichen or twigs with hair linings, in trees. 4–5 cream or pinkish eggs with dark markings. *Figs. 1 Male, 2 Female.*

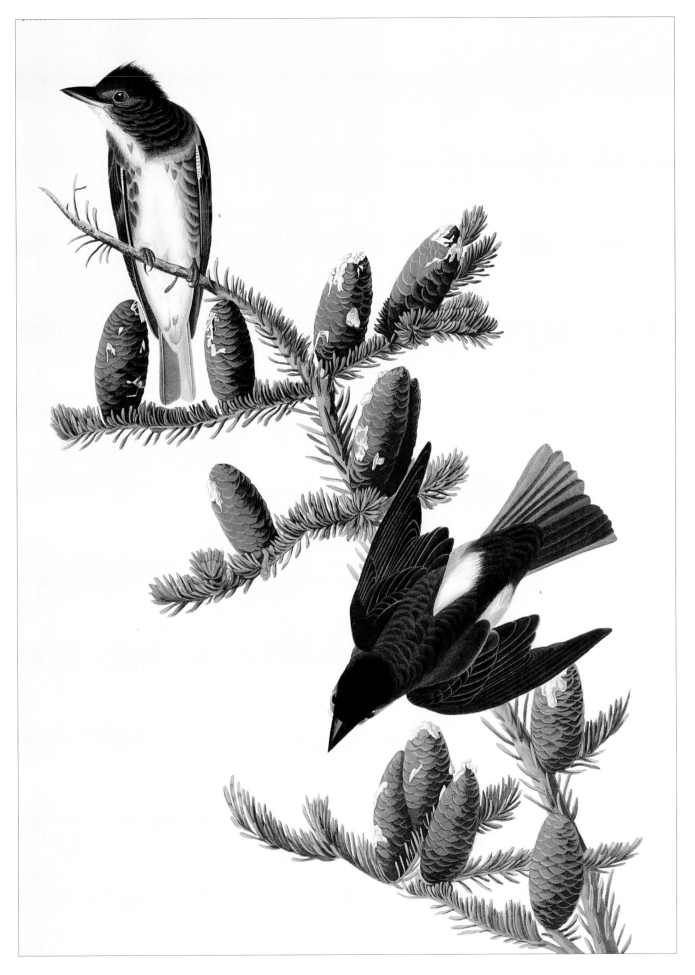

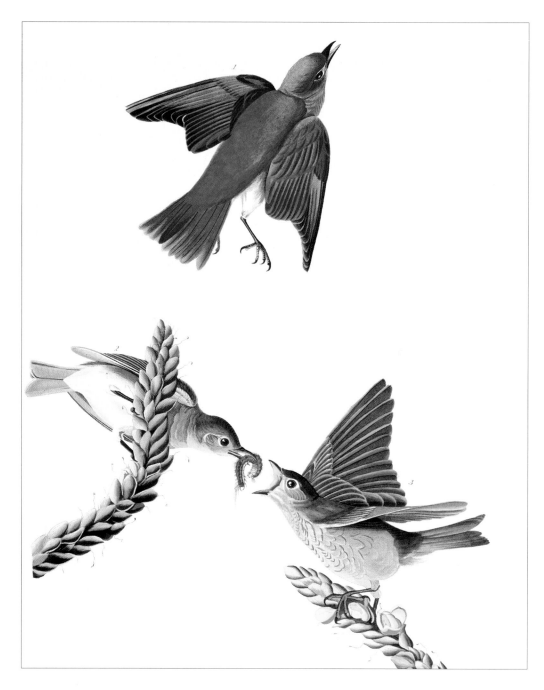

PLATE 46 above
BLUEBIRD (EASTERN BLUEBIRD)

Sialia sialis. 7 inches (18cm). Resident of open woodland, orchards, farmland, and areas of scattered trees.
Distribution: Breeds in eastern and central North America and Mexico, abandoning northern parts in winter. **Food:** Insects, other invertebrates and fruit. **Nesting:** In cavities in trees, in stumps, posts or bird-boxes in which a loose cup composed mainly of grass is constructed. 4–5 pale-blue eggs. *Figs.1 Male, 2 Female, 3 Young.*

PLATE 47 opposite
WINTER or WOOD WREN

Troglodytes troglodytes. 4 inches (10cm). Nests in woodland

where there is low cover, also in dense scrub and moist conifer woodland. **Distribution:** Breeds along the west coast, and across Canada to Newfoundland and New England, wintering in the southern United States. **Food:** Insects and small invertebrates. **Nesting:** In a loose domed structure with feather linings, built into a recess. 5–8 white or speckled eggs. *Figs. 1 Male, 2 Female, 3 Young in autumn.*
ROCK WREN *Salpinctes obsoletus*. 6 inches (15cm). An
inhabitant of bare rocky slopes, rocky outcrops, gullies and scrubland. **Distribution:** Resident in south-western United States, deserting the more mountainous areas in winter.
Food: Insects, small invertebrates. **Nesting:** In a cup of fine grass lined with wool and hair, in a rock cavity or crevice. 5–6 white eggs with small dark markings. *Fig. 4 Female.*

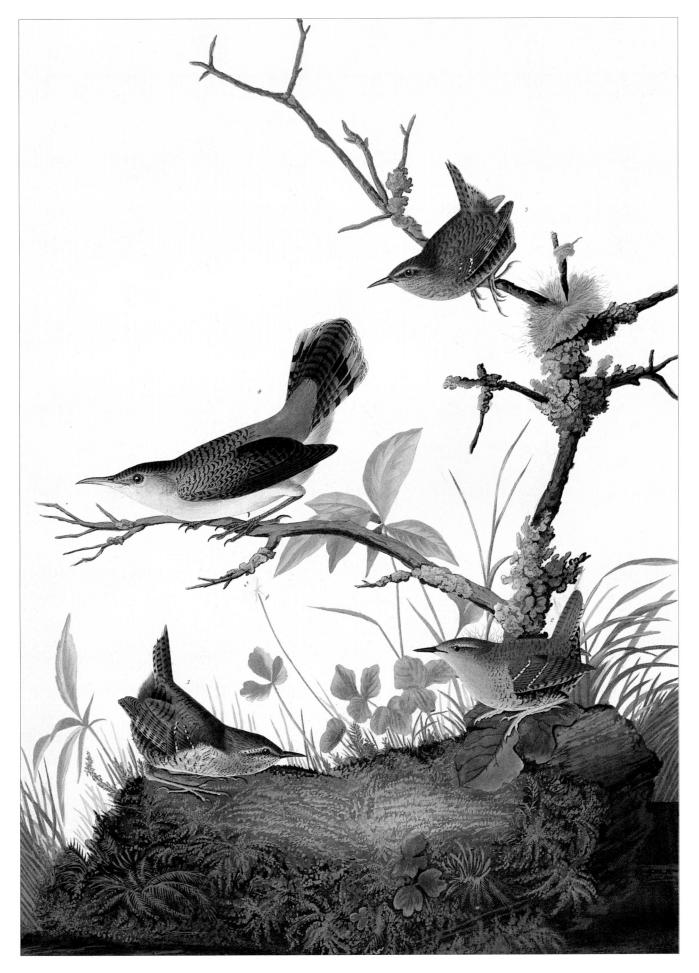

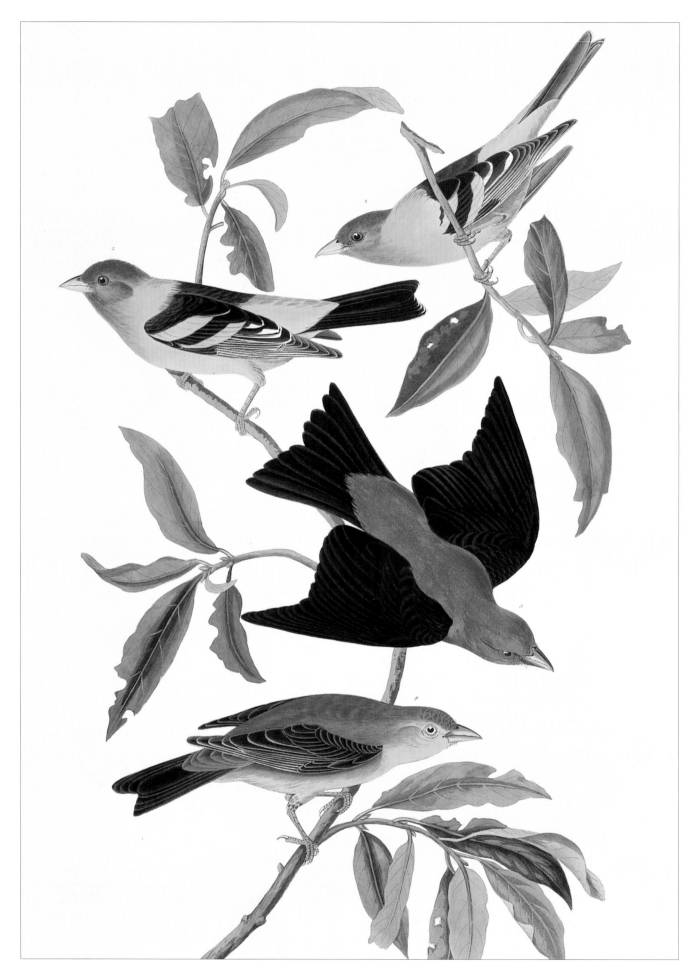

PLATE 48 opposite

LOUISIANA TANAGER (WESTERN TANAGER)

Piranga ludoviciana. 7 inches (18cm). A bird predominantly of woodland. **Distribution:** Breeds in the western half of North America, wintering in Central America. **Food:** Fruit, small invertebrates, seeds. **Nesting:** In a stout cup of twigs, rootlets and moss with finer linings, mainly in conifers. 3–5 light-blue to greenish-blue eggs, finely speckled and spotted with darker marks. *Figs. 1, 2 Males, spring plumage.* **SCARLET TANAGER (BLACK-WINGED RED-BIRD)** *Piranga olivacea.* 7 inches (18cm). A bird of broadleaf and pine-oak woodlands, and orchards. **Distribution:** Breeds in the eastern half of the United States and south-eastern Canada, wintering in South America. **Food:** Fruit, small invertebrates. **Nesting:** In a shallow, loosely-woven cup with finer lining, usually in a twig fork. 3–5 light-blue to greenish-blue eggs with fine reddish markings. *Figs. 3 Male, 4 Female.*

PLATE 49 above right

CARDINAL GROSBEAK (NORTHERN CARDINAL)

Cardinalis cardinalis. 9 inches (22cm). An inhabitant of thickets, open woodland, areas of vegetation along streams, and gardens. **Distribution:** Resident in south-eastern Canada, east-central and south-western United States. **Food:** Seeds, fruit and insects. **Nesting:** Constructs a cup in a shrub or vine. 3–4 white eggs, with variable small dark markings.

PLATE 50 right

BROWN CREEPER (AMERICAN TREE-CREEPER)

Certhia americana. 5 inches (13cm). Favours woodland, where it shuffles up and down the trunks and branches of trees. **Distribution:** Breeds in the north-east and west of North America, wintering across the United States. **Food:** Small invertebrates in and on bark. **Nesting:** In a crevice or behind loose bark in a loose cup of twigs and plants with finer lining. 3–9 finely speckled white eggs. *Figs. 1 Male, 2 Female.* **CALIFORNIAN NUTHATCH (PYGMY NUTHATCH)** *Sitta pygmaea.* 4 inches (11cm). Inhabitant of coniferous woodland, mainly in mountains, where it will congregate in noisy, active social groups. **Distribution:** Resident in the west, from British Columbia to Mexico. **Food:** Small invertebrates and seeds. **Nesting:** In tree cavities, often excavated or enlarged, in soft-lined cups. 5–9 eggs, white with reddish spotting. *Figs. 3 Male, 4 Female.*

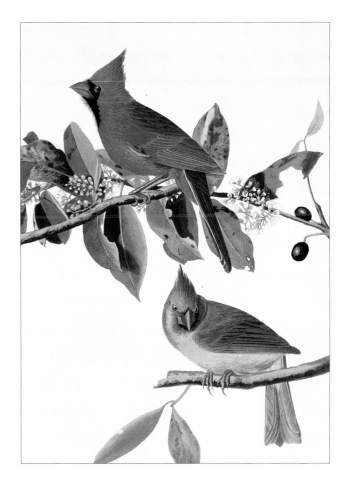

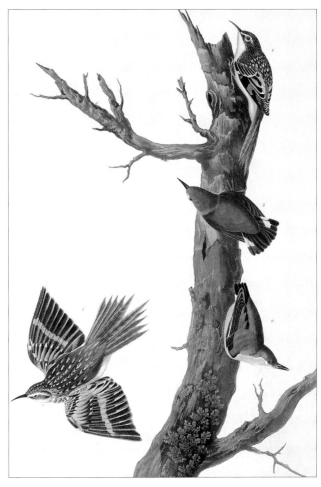

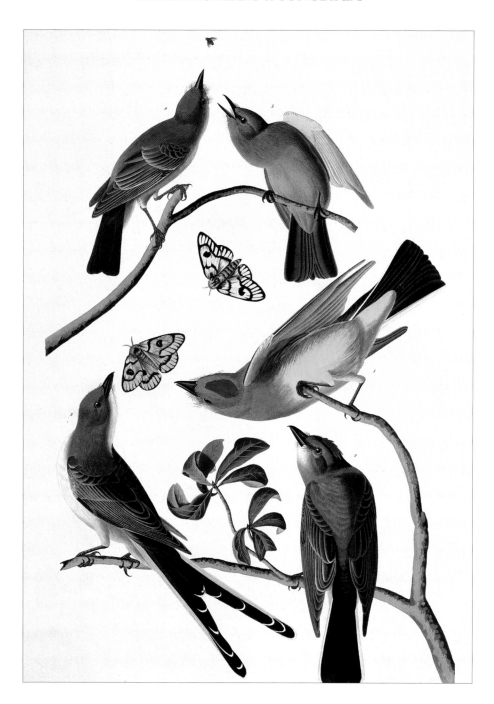

PLATE 51

ARKANSAW FLYCATCHER (WESTERN KINGBIRD)

Tyrannus verticalis. 9 inches (22cm). Perches conspicuously in dry, open country. **Distribution:** Breeds in the western and mid United States, wintering in Central America. **Food:** Mainly flying insects. **Nesting:** In a large, untidy cup with finer linings in trees or shrubs. 3–5 white to pinkish eggs with dark markings. *Figs. 1 Male, 2 Female.*

SWALLOW- or SCISSOR-TAILED FLYCATCHER *Tyrannus forficatus.* 13 inches (33cm).

A perching bird of open country and scrub, its long tail-feathers are conspicuous in flight. **Distribution:** Breeds in the western Gulf states, wintering in Central America. **Food:** Insects, mainly caught in flight. **Nesting:** In loose cups of thin debris on a level branch or tree-fork. 3–5 brown-blotched white eggs. *Fig. 3 Male.* **SAY'S FLYCATCHER (SAY'S PHOEBE)**

Sayornis saya. 7 inches (19cm). A perching bird of dry open areas of rocks and sparse vegetation. **Distribution:** South from Alaska, wintering and resident from the south-western United States to Mexico. **Food:** Insects. **Nesting:** In a bulky cup of plant material bound with spiders' webs, in cavities. 4–5 white eggs. *Figs. 4 Male, 5 Female.*